D0375948

TIONA NEKKIA MCCLODDEN

MASK / CONCEAL / CARRY

CLARION

TIONA NEKKIA MCCLODDEN

IV

Contents

Curator's Note: Carrying
Ebony L. Haynes

Language, in its many forms, wields power—bodily, verbal, textual, conceptual, it provides the means to communicate with one's self and others. Tiona Nekkia McClodden's exhibition *MASK / CONCEAL / CARRY* explores what it is to create and interpret language. Together, the works in this show pivot around the idea of "training to failure," resulting in a conversation and mapping that is uniquely possible within 52 Walker's program.

The phrase "training to failure" comes from the world of weight training. It holds that, in order to make progress, you need to carry more weight than you can handle; to achieve gains or to succeed—a success measured by and set in accordance with someone else's standard—you must continue to strenuously lift something that is inherently too great a load to bear. McClodden is acutely aware of the body and its correspondence with the boundaries of the psyche and the spectrum of pleasure and pain. How sound, light, cultural history resonate on the body manifests in her work. Training to failure is also linked here to "dry-fire training," or shooting without ammunition, the movements of which McClodden tracks in her videos (see pp. 54–61) and line paintings (see pp. 45–51). Dry shooting allows data to become legible, where a person's demeanor is traced through line. Here we read motive, intention, and speed, calmness or agitation. McClodden uses Kydex to contour over pistols and ammunition from her own collection. Even the sculptures, inspired by Benin bronzes, take on the shapes of gun accessories (clips, magnums for AK47s) but allude to the figurative bodies of soldiers.

Encompassing the personal, historical, and mythic, the exhibition considers the presence and absence of the Black figure and the aesthetic strategies of illumination and opacity that subvert available modes of representation. The terms "mask," "conceal," and "carry" each hold a singular meaning as much as together they collate various interpretations, both socially and personally to the artist. For McClodden, "masking" and its inverse, "unmasking," relate to assimilationist tendencies she has learned and attempted to unlearn in the context of her autism. "Concealing" raises conditions of one's identity or the obstruction of truth, as well as associations with firearms, which are further reinforced by "carrying." Additionally, "carrying" evokes the weight of complex psychological components and the burden of bearing trauma. Through language, in its various forms, intentions, and manifestations, this exhibition meditates on embodiment and the binds of rage versus composure.

This volume of *Clarion* offers an opportunity to experience the exhibition in reverse, granting access to much of what McClodden held close while working on the show. McClodden has filled the following pages with images and a selection of poetry that invite us into her studio, the shooting range, and her process. She elaborates on her approach and thinking in a conversation with Simone White and in a text she has contributed to the publication. She and White discuss Hype Williams's feature film *Belly* (1998), which was a point of inspiration for McClodden and me as we were formulating the show itself. The opening nightclub scene in particular, in which the Black figures (Nas and DMX) are augmented, traced, and celebrated by the black light, informed the lighting for the exhibition. Somehow the darkness illuminates the surface, texture, and material quality of the bronzes, Kydex reliefs, fabric targets, and paintings; in this darkness, black is truly seen.

DONALD DAHMER

RHEADILON

Have you ever considered yourself as a moving target?

BLANK

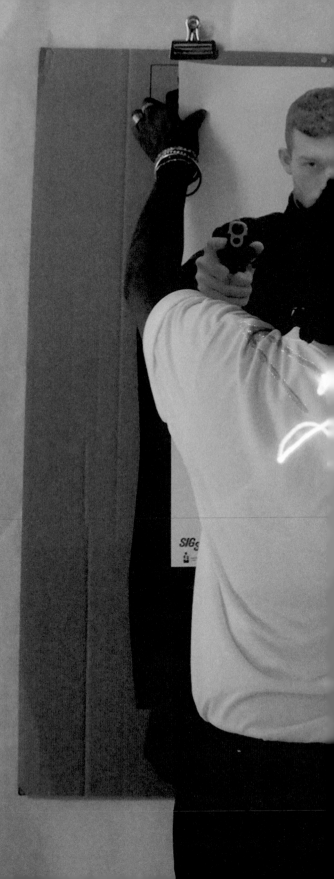

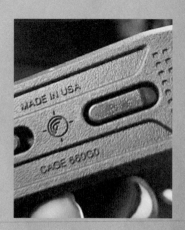

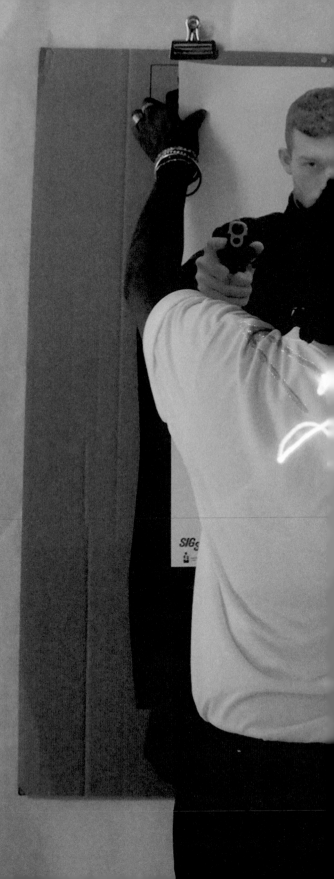

VE MEASURES HAVE BEEN TAKEN TO
NG OF ALL EXPRESSION. YOU NEED F
BURGEONINGS OF UNIMPEDED AND DIAP
S FROM LOVE. IRON GLOVES FOR A
TENT IS TO KEEP THIS FREEDOM SH
PUKES AT THE SIGHT OF DAY. ON
THERE WILL BE NO RESISTANCE T
NG ITS ENERGIES TO MORE MATERIAL E
I AND ITS COLOR WILL BE HARDENE
D, AND THE FURY AND ANGER HA
MANY EMBITTERING INDIGNITIES SUFFE
S OF OUR FREEDOM BUSTERS WILL PROV
GY WE NEED TO KEEP OUR EVIL GOIN
WEVER, REMAIN VIGILANT: THE POE
VILL INEVITABLY RESORT TO THE MOS
S AND OTHER EVILS IN ORDER TO SECU
YOU, KNOWING NOTHING OF MERCY, WI
DED BY ITS CRIES, BUT DO BE EXPEDIE
THE FIRST WHIMPER, AND BEAT IT VIOL
OME SUNLIGHT STREAKED WITH FRATR
TO ITS FACE AND DO NOT BE REASSURED
ON UNTIL THE PUKE RUNS ACIDIC GREEN
RILS. LOVE AND FREEDOM WILL HAPPILY
OUTHS SHUT, AND THEIR CHILDREN WILL
R HEADS ON A PLATTER—NO QUESTIONS A

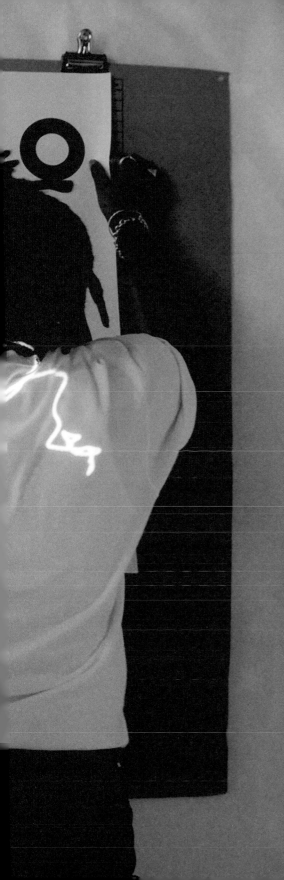

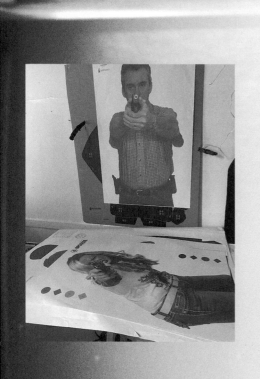

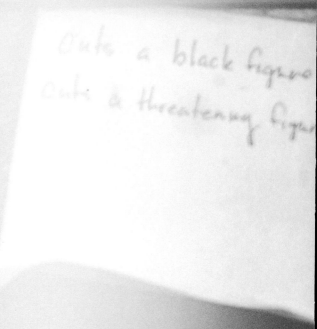

Onto a black figure
Onto a threatening figure

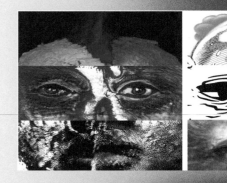

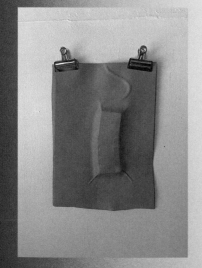

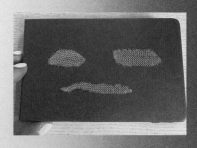

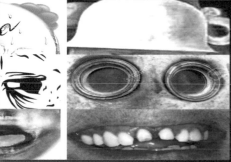

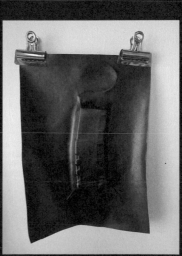

Protective Figure
"Body guard"

Shrinkage — Writing

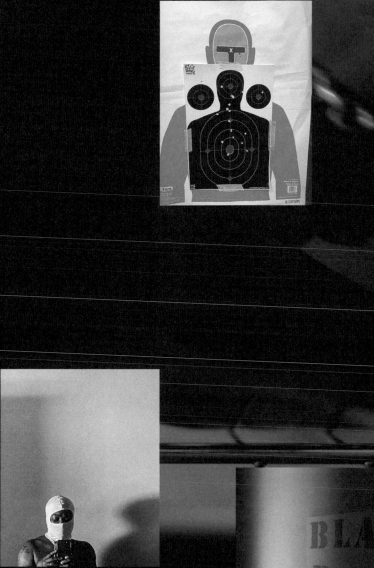

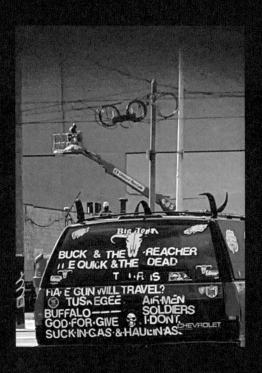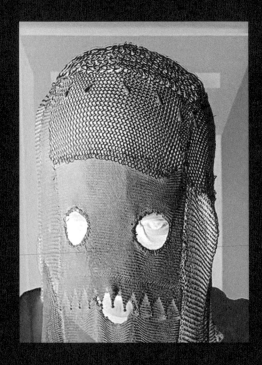

DOG POEM

On this day 11 years ago my father died.
I watched him refuse death.
There was no reason to share this.
It was an indignity.
There is no refusing.
The brain stops even if until the last it performs miraculously the
 duty of remaining illuminated.
He died on an evening like this warm one in November.
Loose leaves blew around the parking lot as I drove away from the
 place of his death, a hospital.
I smoked with my mother's second sister just beyond the gate of
 the house my parents bought, owned and lived in together for
 twenty-six years.
I lived in that house, but did not live there then.
We smoked and a reporter came to the gate and asked her
 questions.
She was ashamed.
There was no need to answer her.
We did not answer.
We smoked.
The night was strangely warm, like so many peculiar Hallowe'ens,
 November in just a few days.
Autumn quiets or casts itself between the warm parts of air.
It fills spaces of warmth with cold.

On the eastern seaboard of the United States where now there is
 nothing like the four seasons we knew as children, I suppose
 I have come to understand ecological disaster in these limited
 terms, as fallen evening, as a reflection of a more general
 limitation of world ideas, inability to enter into discussions of

$18 POETRY / ESSAY
UGLY DUCKLING PRESSE :: DO

structure or apparatus without the help of lyric rendering.

It's not a matter of incomprehension—evening for death.

Vacant shacks on land the size of a town that once belonged only
to my family deep in Scott County, Mississippi;
this for mine, or ours, and also, guns.

I first touched my grandfather's beloved hunting weapons at this
"homestead."

Touching, an act that did not resemble in any way the late
experience of inspecting, loading and discharging a 9-millimeter
handgun.

Range shooting was an activity my father enjoyed, found amusing.

The unnatural power of tiny hand canons is disgusting.

When I found that my hands were neither large nor strong enough
to manage an automatic weapon of this kind, for the first and
only time in my life I shook all over, my arms and hands were
shaking.

I could not participate further or again in this kind of family outing.

My family thought nothing of this.

There is one story about me as a melodramatic type—a swooner—
which is utterly ridiculous.

Someone suggested a smaller gun, a .38-caliber revolver.

Apparently this was the gun for a woman prepared to manage the
killing of a human person.

Now the local tragedy of my father's death passes.

It has passed through the writing of these sentences.

It is past.

The fleetness of death is most impressive, crushing in its casual
completeness and simplicity.

The brain stops.

The heart stops.

Then there is no more breath, a sign that life has ended, its signal
end, I suppose.

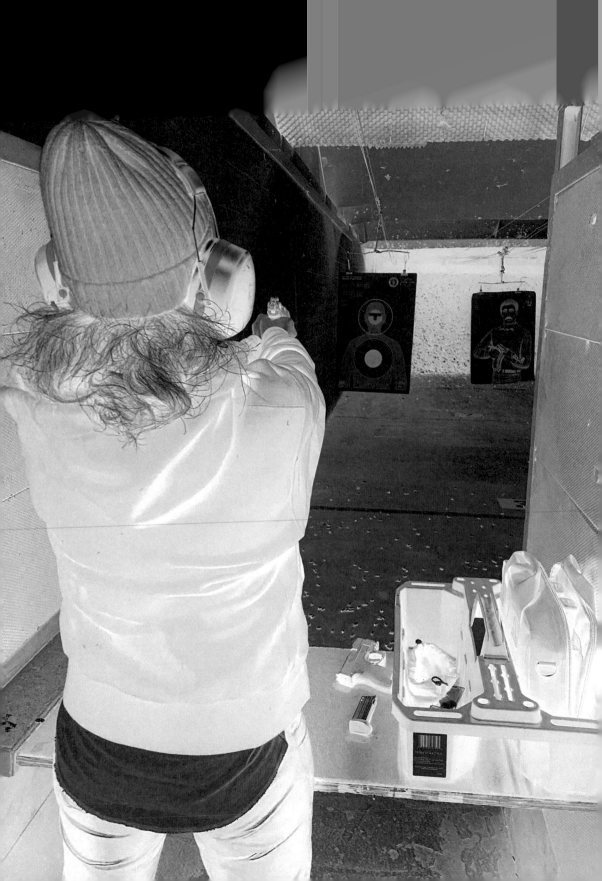

In Conversation
Tiona Nekkia McClodden and Simone White

Simone White: When you do work that is tied to any kind of biographical element—thinking about autoethnography—people feel that, when you do that work, you have to give them access to your entire life.

Tiona Nekkia McClodden: *MASK / CONCEAL / CARRY* began with me trying to have a conversation with myself, asking, "What can I keep for myself? What am I going through in my life? What is my reality?"

I am not interested in creating a disturbance in the different spaces that I enter. When I've worked with someone else, I don't have any recording device. I'm not writing notes. I'm talking to them. Then we work our way to this place where maybe I could get to the documentation.

But I do that with myself as well. When we did press for the show, *The New York Times* asked if they could bring a photographer to the gun range. And I said no, the interviewer is going to have to go through this process that I went through—you have to feel it in your body and do the recall. We're not going to have a photographer be something that changes the dynamic of the space that I go to. Because this is my range and I'm still going to go here and I don't want to talk about *The New York Times* being here, because that is going to disrupt what Philly does for me, which is create a place for me to be held.

And so with the exhibition, I like that I was able to keep a very significant process private. Though this publication gives more of a reveal of what the work presents.

SW: I've been thinking about how Black people are required to show up personally. Once you expose yourself to the institutional demand to be part of their apparatus or whatever, there is an expectation that you are there to meet consumer demand for your Black presence. There is a fascinating tension in the way you've staged the performance of shooting that seems to have something to say about that demand. You've said the work might allow you to hold something private or escape consumer demand by requiring the viewer to have to have some kind of experience, or not.

You could regard all the objects in that space as dead objects and totally disengage from them. Or you could engage with them as the material that they seem to be: the material of violence.

TNM: Exactly. So many people are hungry to develop an empathy through you as an artist. Because my work has always included elements tied to various identities or times in my life, I've been faced with thinking about a viewer who is trying to live through my experience. Which is why I try to stay away from ideas around social change, because that's a direct invitation to develop empathy through a particular kind of experience tied to art. I'm looking for my own epiphany. I do work that puts me in a place to be able to figure out a feeling, to see if something is real or isn't.

Sometimes I even confuse myself. With this show, I had skin in the game—in the sense of there's a disclosure that I'm a "shooter." But what does it mean to say not only am I a shooter, but these are my guns that you're actually looking at. This is not a hypothetical or me borrowing something or trying to figure something out through somebody else's experience. The works are casts of my items, of the residue of the calibers that I've shot. These graphics are my shots. I want to exploit or create my own exploitation of my Black data. Black data is so valuable.

What does it look like to look at this as a data show? In many ways, it is more about how to deal with violence that doesn't require a cadaver, or to think about this idea of stasis, in that the art world right now is very obsessed with Black death and the Black body. That language is a little frustrating for me.

I put my own physical being, my body, in the show. I'm interested in myself as a figure. I'm interested in the walk. I'm interested in people trying to make the correlation of that to the actual data on the other side of the gallery space, to see if they can transfer that idea of body into data or into this gesture or mark.

I knew that I was going to be up against a lot, which I did not really understand until it was in the fourth quarter of doing the show, because of the reality of how gun violence had picked up. Because it keeps picking up. I realized that I had to be a bit firmer. Periods at the end type of thing, with this being my experience, and this being the residue of my actions.

SW: You're objecting to the idea of the Black body. Do you think that that is ultimately just about a dead body?

TNM: Yeah. When people say the "Black body," I challenge some of my peers and the academics and I've started to say "cadaver," and people are really shaken by that. I'm just like, What are you saying here? Why does it have to be the "Black body"? Can you talk about your own personhood? Otherwise you've assigned this person a particular debt or a stagnant position that they're not able to move outside of, even if it is a theoretical one. Often language is used in these "theoretical spaces," and I'm seeing Black folks use this as a way to distance themselves from certain aspects of Blackness or Black people. Then it's an assignment of the Black body. I mean, this could be a byproduct of my autism. Because sometimes people say stuff to me and it shows up in my head as very strange. When people say "Black body," I'm like, Are you talking about a Black mass? A mass of people? But most times, people are talking about an individual.

SW: What other aspects of Black life are you thinking about?

TNM: Violence or the more abject or the more fetishized. I think about Blackness as being both abject and fetish. Have you ever heard anybody in the streets say "the Black body"? Nobody's saying that. So when people do, I'm like, Oh, you're trying to distance yourself from this particular understanding of Blackness. Or this idea of Blackness you can identify with but want to wield a certain kind of language-power over, in relationship to what that distance can actually yield within these particular theoretical and academic spaces.

SW: The "Black body" is not the vernacular. How do you understand Black people to talk about

their experience then? If you're talking about a Black gaze or a Black body, you're trying to enter into a certain kind of discourse about looking that has previously been owned by white supremacy. I try to think about what is happening in actual Black communities, how we actually talk to each other, what we actually love and enjoy, what we actually don't want to talk about. I think of the way I walk around Bed-Stuy in Brooklyn and observe everybody and think of what people are telling me by the way they move.

In your show, what I'm seeing is that you are interested in a more physical rather than linguistic expression of communication and sociality among Black people. And the ways in which that communication and sociality is often involved with violence.

TNM: You say "I," "me," "we." To me, it's that simple. You don't say "them," "they," "Black body." The experience of centering Black subjectivity comes from being in Philly. In Philly, I am able to read the gestures of Black people and understand, before language, whether I'm safe or whether something is wrong. And there's a certain kind of vernacular, I think, read in that which is reminiscent from the South. When I moved to Philly, I was able to bring things that I had grown up with into this space.

SW: People say it's the northernmost Southern city.

TNM: I moved to Philly because the South had run its course. I realized that I couldn't be in a place where the common baseline, especially with art, was a reminder that you were enslaved all the time. I couldn't escape it in the HBCUs, I couldn't escape it in the artist community, and I couldn't escape it in the film community or the punk scene that I was a part of. In Philly, even though there is this legacy of proximity to enslavement, there is also the free Negro. This is a place where I can be quiet enough to be around folks at their loudest. Philly people are *loud* when they don't talk. There's a lot of movement. A lot of the ways that you have to read around violence is gestured. A lot of what I observed when I was at the shooting range was

gesture. I showed you the intro to the movie *Belly*. To me, in its own way, it is kind of this announcement of a physical presence.

SW: It's so beautiful. Thank you for showing me. I presented a video that is a two-minute loop of Bobby Shmurda just moving his body to this Jenny Hval song. It's not about the "dance." It's more about swagger and the communication being of an erotic nature. I think about desirous communications, the way we communicate love, the way we communicate threat, the way we communicate all these things through clothes, before we say anything. And the ways in which that communication or gesture can be a celebration. You feel it. That's also why I love clothes.

TNM: We understand the language in that look. We understand posture. That's the gift of the Diaspora, because it crosses the way I see a lot of my friends from all over the world. For me, it's been crucial since I was a kid, struggling to communicate, having a lot of nonverbal periods. There was a lot of looking, a lot of trying to figure out how to express need through how I held my body.

SW: Beautiful. I was thinking back to our previous conversation, and I just love the way you talk about the figure and shadow. This really does seem to be a different understanding of how persons manifest themselves that does not refer to interiority. It's not talking about what they think; you're thinking about the shadow they throw, the outline of the person and what is possible through that communication. Obviously, the mind is involved, the human self is involved, but it's like, How can I show you? How can I demonstrate to you through how I throw light, or something like that? That's different from interiority, profoundly different from an abstract idea of the body.

TNM: I said to you, "Oftentimes I feel more like a figure than anything else." It has a lot to do with the anticipation of movement. And it's not interior. There's something that is disrupted in space in real time, something that I'm mindful of that creates a certain kind of legibility or illegibility

of who I am or what I am at any point of the day. And within one reading from one person, I could be a lot of different things. It's akin to the way I think spirit can be read on people as something that's around them, or glitchy around them.

There's Blackness and then there's the figure that Blackness casts on it and what it holds, and then people's perceived ideas of its possibilities.

That's what I was getting with the Kydex, the material used to protect a gun—it's what you clip your gun into. For the show, I wanted to document dealing with Kydex, "cooking" it in the toaster oven. I heated it up to where it gets malleable and then would vacuum press it to take the air out, so it hardens and takes form. During the process, I realized I found a material that does something around the idea of the figure I was trying to get at—something that can collapse into itself and evade a certain kind of legibility. I'm trying to challenge this idea of silhouetting, which is a larger conversation about what I'm experiencing as a Black person, at this time of violence, who could be read as a threatening man.

SW: There is the question of skin, or misreading of the skin, which you're working through with this material, saying there is a reality to Black skin, the surface of Blackness. On the other hand, you have the whole body, which is then in silhouette. For me, these are equally complicated but different conversations about how one is or how one is embodied. But for you, they seem to be the same.

TNM: I'm ultimately capitalizing on the politics and legibility of what a silhouette is with the figure or form that pushes through the material. I think the idea of the figure is uncontrollable, whereas the silhouette is something you can impose your idea and politic on. So I think the way I've moved through the world as a Black dyke with a masculine figure who wears these clothes—people don't look at me, they see me at a glance in a particular way.

SW: For you the metaphor of figure means a shape, then. A shape that corresponds to a category of being.

TNM: The legibility of desire. I think I mess with a lot of people's ideas around desire and abjection. Or fetish. I find it fascinating, and the silhouette is the same in a more violent setting. I don't think of it as a negative when people misread me not just as a masculine figure but as a man. I think of it as something that almost breaks apart a certain idea of what a single Black figure can possess, in terms of the ways that I can hold space or how I talk versus how I look versus how I move versus how … should I be. Do I have a gun on my waist, or do I not? These kinds of things became notes in my study, because I started to look at Black folks on my block. I started to look at the guys differently. I had to, because many started wearing *shiesties*. I started to look at movement more in their bodies, and then it became something extraordinarily beautiful. Some of these guys, I was like, I don't know if you're trying to give a threatening figure, but you're giving a feminine figure. I can see your hips move.

SW: One of the words that comes up in relation to the material and the titles of your work is "ruthful." What does it mean to you?

TNM: I remember going to Toni Morrison's talk at the Free Library of Philadelphia, where she was presenting *A Mercy*. She said the most difficult word she ever used was "ruth." When I came to the language around the bronze works, I thought of them as monuments, but also as anti-monuments. They're things people wouldn't think to memorialize. They're almost an offering. But they're also a war cry. The bronzes embody the songs and cries, the "fiefs of ruthful specters."

SW: The bronze works act similarly to the figures suspended in Kydex. I've been imagining the process of squeezing and reshaping a figure that is resistant. But the bronzes are almost the opposite.

TNM: They're hard, hard and stuck. I decided to do bronze because they had to be fabricated. They're difficult to make, because of the grooves and to get them so they had stealth. It was a space to deal with the idea of caliber, which I think is

important. At the end of the day, the gun doesn't have any value without the caliber. I've been thinking about this other thing that comes up around the idea of mass shooting, where we're dealing with the mass shootings of one Black figure. One person. One body. Ten or more shots is a mass shooting. It has the same effect of lynching. I have been thinking about what it means, to be able to hold a mass shooting in your hands. The monuments, the bronzes, hold all that information because the calibers I'm using at this range are high. It's fifty each, the hundred shots; those are mass shootings. The devices in the show suggest the caliber and its excess.

SW: We should probably talk about the range a little bit. It does feel like a private experience. The thing that I thought most was: Tiona does this every day.

TNM: At least two or three times a week.

SW: You've become accustomed to it. My mother used to be like, You *can* get used to anything. You can get over anything. Pretty cynical. You can get accustomed, but I was in there jumping out of my skin. It's so loud. And then once the people came in with the Dracos, I was like, I can't really be in here no more.

TNM: It was even worse than I wanted it to be. I was embarrassed.

SW: It wasn't you. You go in there, you're doing your practice, your meditation, your work. You can do that in a scene which is relatively quiet. There were not a lot of people at the range in the middle of the day. And there were no white people there. Once a lot of folks started coming in, it actually became a social scene. So, when I went with you, I was like, Oh, this is actually a Black social space.

TNM: Absolutely.

SW: But it's not a Black social space that theorists of Black liberation want to engage with, because, guns. And I think theorists don't want to engage with it because there is no way to control what goes on with those guns once you get out of that regulated space. I have no idea what those folks are doing at the range. I don't know why they go there. I don't know why they got that Draco. So, there's no way for me to make a moral argument about what's going on in that space.

TNM: Exactly. It's the wildest shit.

SW: And it seems to me that that is actually what is missing from Black studies, a direct engagement with the aspect of Black social life that is on the inside of what I call "warring" (I stole that word from Chief Keef), an engagement that is not diagnostic or sociological.

TNM: Exactly. You definitely hit the nail on the head with the moral high ground. There is none. I don't have a moral standpoint. When I enter in that space, the range, I don't know who these folks are. I oddly have to bring it to another space that I've entered and occupy a lot, BDSM dungeons. These are spaces people are coming to from all these different places of desire. Many I don't have *any* interest in, or don't agree with, but we are in this architectural space because there's something that we all need here. There's a protocol to the space and there's an inherent respect in the space. The gun range is the same. I know that there's no reason for half those people to have the guns that they have. Including me.

SW: This is why I cannot be messing with this 9mm pistol. That's my threshold. To me, the only reason to handle a gun like this is to kill someone. So to me, if it comes down to somebody and me with the nine—I guess I'll be dead.

TNM: It's a scary device. I have an AR15, but I did not bring that into the space because I didn't want you to see the image of me holding that. Because that goes into a whole other kind of protocol in a space. I'll never shoot that around anyone, because it's a fearful image. It's an abject object. I don't have a desire for it. I don't like it.

But because of the reality of not only what you saw at the range but also random people, white people, who are citizens and neighbors who were carrying AR15s, I was just like, I have to get familiar with this. I need to have this because I need to knock the fear off of it.

SW: Let's talk for a second about fear, or the confrontation with fear. If faced with having to arm myself with an AK in order to survive, I'm not sure that I would choose the option of arming myself. I mean it is somewhat apocalyptic, right? These are white supremacist end times, where we actually see, possibly, the demise of white supremacy, however long that tail might be, and so you choose to arm yourself in the face of this. So in a way, the fear is not of death. To see you engaged in the work, the exhibition, everything that we've talked about, it seems the fear is in being caught unprepared, being confronted and not being able to do the Frederick Douglass move. Your position is that no one is going to take your freedom from you. We are going to have to fight.

TNM: Yeah. Straight up. I always want to be ready. There was one moment where I was just like, I'm not ready. I didn't have the things it would take to, really quite frankly, protect my home. It was so crazy. I didn't know what was going to happen during these uprisings. I don't think a lot of us did. But then the biggest fear reared its head after I felt very secure in being able to shoot well. I haven't had to use a gun in a live situation. And that, who knows what will happen despite all my training, my fear was of becoming a sociopath.

There was a moment I had to catch myself, because the fear was palpable. I was having such a hard time, shaking and not being able to get stuff off my skin. But there's this other thing where I was very afraid to push through, because what if I did conquer it? I kept allowing myself to be in this space. But what if I get so good that I become completely dulled out.

Every time I'm in the range, the first gunshot shakes me, whether I'm shooting it or somebody's shooting around me. And then I fear, when I'm breathing and I get into it, there's something

getting me closer and closer to something sociopathic or like a soldier; a thing of tolerance.

I don't want to tolerate that. When I'm in Philly and know I have to be in the studio later, I carry my gun. When I'm pulling up, there's a certain way that I hold it. After a while, I would catch myself, and I was like, Damn, I'm getting too good at this. It doesn't alarm me. It's very natural. And I think about peers of mine who also carry a gun, because of gangs, because of what they're moving with. And here I am, an artist. I'm not exactly involving myself in these kind of things.

SW: I have to tell you, the murder of Takeoff, from the Migos, really freaked me out. And it was partly because I think about you or other people who really ought not, in a certain narrative, have to be exposed. There is an aspect of the work that involves re-exposing yourself. How does the work regard reentry into a danger zone? All Black people are supposed to desire to never reenter, in a certain respect—this is the central preoccupation of a liberal Black politics—and so it is a complicated narrative about what Black people desire for themselves as freedom. The desire to reenter this dangerous place is a different kind of freedom. It's like, I actually choose to not be completely safe. And it's very powerful and it's also very sad.

TNM: It's extraordinarily sad. One of the sadder parts is when I had to go purchase one gun and realized I needed a different one to carry. And then a different one. The gun that you were shooting with, the 22mm, that's my concealed-carry gun, because if I shoot someone, they'll more than likely survive. The 9mm, that's different, and the AR is like, I don't care, anybody can get hit.

And that's sad as fuck. For me, there's a personal sadness because of my position in my family. As a military kid, I saw what it did to my family, did to me. It's a horrible system, and I swore that I wouldn't be a soldier. But then going into this place where you realize you have to soldier for yourself, and the gender element peaked.

Lord knows I've done some really wild stuff. But I'm not a nihilist. I'm fascinated by the individual

who is not interested in surviving nor in the people around them surviving. I don't understand that as a basis of friendship, but I do understand that to be a male social formation that has started to really take hold.

SW: It's not a new formation, but the intensity of violence and the availability of guns is new. I wonder about your sense that you're a target.

TNM: It's just because I've been targeted. I came into Philly during the stop-and-frisk era, and I had two incidents of being stopped by the police, because they thought I was a guy, and it always happened in the winter. It's the most terrifying thing ever. I couldn't believe it. You look up and there's three cops. You're cornered. It just happens out of nowhere. On the train platform.

And Black men are just trying to figure out who I am. It's always made me feel like a target. A lot of the things that Black men have lamented over I've also had to lament over. On top of all the things that Black women lament over. Because I do feel like there is an immense threat. I am seen as a certain kind of figure.

I've talked about this in my therapy a lot this year. It's really hard to think about doing this work, which is wrestling with all of that and trying to take a power position. But then putting myself back into this position where I become a larger target within these different formations. Whether it's a social one or within the art world. I do ask myself why do it. But it's the only way I feel that I can make my art. My impulse to do it is about making a statement. Because I wouldn't necessarily be called on to share my experience. Nobody is going to ask me how I feel about this. Ever. I'm not an academic. I'm not even in the art world socially. So when I made this work, I was like, I'm going to do this. I'm going to be proactive. I want to say something, to say this is how I feel right now because of that.

I want you to talk to me about your experience in the range and what it felt like to shoot, what it felt like in your body, and how you thought about it after that experience.

SW: Well, as I said, I have a very strong sense that I do not want to participate in that kind of violence. On the other hand, you have almost convinced me that I need to get my own gun. I'm aware that many people are armed. I do not feel threatened because I'm not a participant. I'm a civilian. I try to think of myself in the ongoing war. I actually don't want any part of it, because I am not a soldier like that. Maybe because I have spent so much time trying to defend my softness and vulnerability, to fight for it. My father used to call me a soldier when he approved of my bravery. It's not like, Oh, that's a masculine thing. I feel very strongly, like I said, that if I have to be hard, be a killer or a shooter, then actually I don't want it.

I think your work is a convincing argument about the true state of things. I'm an achiever, so you tell me you want me to do X, Y, and Z and I'm like, Well, all right. I'm going to try to master it in the moment. Plus, I don't feel uncomfortable around you, and I know you're not going to let anything happen to me. I did understand the protocol of that situation and recognize that if anything were to jump off, somebody else was more likely to get shot than I was. You know what I mean? That I wasn't really in danger. But, in a way, I do feel like taking up the gun puts me in greater danger. Because I am a target for all the reasons. And the likelihood that I would have to kill somebody might be higher than I would like. You really opened up a possibility for me, which for many decades I foreclosed, that I would never own a gun. And I'm rethinking that based on the conversations we've had. Not so much about being at the range, because that just activated all my feelings.

TNM: Yeah. I was like, You going to be marching against gun violence the next day.

SW: I'm definitely that person. But you are a soldier, right? The way you handle your guns, your attitude toward the reality of killing, all those things seem very controlled. As we said, too, though, the scene at the range was representative of a situation that is out of control.

TNM: Completely. You got to see what I couldn't dare explain because people wouldn't believe me. It is actually such a Black social space that it gets that bizarre.

SW: This is the thing about contemporary Black experience that I've been trying to think about: the ways in which our social spaces and our communication have gotten so bizarre, partly because they are unhinged from any type of "politics." It's very difficult to accept, and I don't know where it's going to go, but it seems real.

TNM: And this shows up in the space of the range. During this project, I said at one point I couldn't tell the difference between a QAnon and a Hotep, because their rhetoric is so similar. I think we're in a post-politic or -political framework.

Being a Black dyke and a feminist, I hold space in these very strange places. I have complicated and troubled a lot of the social formations that I was a part of before the beginning of the pandemic, just by doing this work and stating my position.

I've been very clear. I have been very explicit about not wanting to entertain and dialogue with social change practice. Like art practice. That has pushed people to ask what this means. Does it mean I'm anti-"this policy"? To which I would say, "I'm anti trying to think that my work is going to do anything for anyone except for myself."

I think that there is something very interesting about Black profanity. There's something very interesting to me about Black unruliness and misbehaving with intention. Intentional misbehaving is crazy. I'm like, Wow, y'all are just wild for real. It's not the drugs, it's not the alcohol. I'm interested in the Blackness that is developing in this state that doesn't want to adhere to formalities. I'm just interested in people who are, for whatever reason, refusing. It's an immense and deep refusal.

WHO IM FINNA TEACH WITH THEORY HOW NOT TO KILL ME?!
Tiona Nekkia McClodden

I obtained my license to carry in Philadelphia in January 2021. This process was years in the works but accelerated by a series of events and scenes that occurred in summer 2020. The pandemic was at its first of many heights, and there were several moments when I was forced to rush home after running errands because white men in fatigues with machetes, and openly carrying machine guns, were physically beating other white men as the cops watched only five minutes from where I live. It was chaos. People were protesting about the inequalities they finally acknowledged being aware of due to their own forced stasis. Police presence was being challenged by those who previously sought their protection. These were white people who stepped forward and were severely beaten in real time in public by police.

This is when I knew.

To get a license to carry you have to go to the one police precinct in all of Philadelphia that accepts the application. It took me four tries. Standing lines the length of two blocks. All of us Black folks in those lines and we were aware that what we had seen and heard of was finally here, yet again. We refused the ignorance and refused to trust that anyone would protect us.

My first firearm purchase was a Glock 48. COVID was the least of my worries.

This work started as a study, a private practice of my relationship to guns. These strange apparatuses that somehow have the nerve to be gendered in their access. I was not given the training as a girl-child, growing up in the South, in the ways that boys were. I wasn't taken on the hunting trips or gifted my grandfather's six-shooter. I seek training from strangers. I was taken to the range by my ex-fiancée's father, she an Asian woman while he a white Republican man. He says that I am a good shot and can protect his daughter. Back in Philly I take my first safety course from a PTSD-infused white man who is former military and can barely look me in the eyes due to his expectation of war in the room. He is an excellent

teacher and I an excellent student. I was invited to be a member of the gun range after demonstrating good form.

I went online to be frugal and save money on targets. They cost too much at the range. Ninety-five percent of the targets featured white people and it shook me to my core looking at the images. What revealed itself next is that these targets are used within different kinds of clearances for police, military, and security forces in gun-training programs. The qualifications vary per state. The scenarios on the kraft paper grid are cinematic beyond reason.

I ordered so many of them the shipping was delayed by a month. I took a few to a range, and it was suggested that they were not the kind of targets that would be good to use because they featured "people." I immediately understood the subtle warning. These targets explicitly featured white people, not the silhouette, and as a Black person shooting these paper targets that would signal *something*. The targets offer a view into the iconography of white madness and, more specifically, the performance of madness, threat, and capture. These are my threatening figures, not the black silhouettes.

MASK.
I'm doing two things here. I mask every day. I put it on and I take it off every minute, hour, day. I masked for twenty years and I am tired. No one knows my secret but me. This mask is invisible. A mask is a device to reveal as well as conceal. Masking is the process of removal as well as hiding. I use a physical mask to disclose my position as a player. I am autistic. I mask it, but I am tired and everyone has to know so that I can begin the process of slowing down the mask. I have tics. I've worked holes in my shirts from the rubbing. I say what I think and it confuses people. I cannot read people and wonder why they lie so much in conversation. I cannot tell when someone likes me unless it's a blatant admission. But

touch. I can understand pressure whether light or hard. Pressure is where I perform at my best. HARD HARD HARD. I am trying to be softer these days. To myself, mostly. To handle myself as a precious thing.

I start with the gun.

Shooting someone twenty times is also a mass shooting. It was never about one figure.

"Anytime you're in a position of centrality, you are gonna be a target." —My therapist

It hurt me to be there. Shot after shot. I hid it for a while but told my therapist that I felt so bad because I wanted to go to the range, but it would take two to three days to get the sound off my skin. It was at this moment when I realized there was a painful element that I had to negotiate that the average person does not. My autism was in the range with me. I felt defeated.

I'm shooting with handguns mostly when I am there. Other shooters, mostly men and some women, are shooting with assault rifles. The sound is overwhelming. I enter the range and spend the first ten minutes loading my magazines while allowing the sound to level its war against my body's senses. Once the sound hits a dulling harmony against my skin, I can start my shooting practice. I think about punk shows and the blast of sound so hard, so dull that blows my senses out to a dull, lush thing that I like.

I listen to Death Grips when I drive to the range to get started. FUCK FUCK ME OUTTTTT.

Eventually, I invested in dry shooting. I have software and a node that I attach to my pistol which tracks my dry firing by measuring the draw, the hold, the trigger, and the release. Ballistics. The information, the emotionality that is around a bullet. The puncture. I want to tame this caliber.

I generate a mark or a signature that is mine, and that is my data. I then decide to exploit my data. I put this data up against another form of data, my DSM-5 graph that charts my sensory profile from my autism diagnosis file. I select the top shots, 80 percent and up, that signify an excellence or good training.

Painting was the only form that would allow me to slow down the information and consider what was happening with the information around the puncture. SLOOOOWWW DOWWN THE MARK.

The canvases are painted in an inconsistent dead-stock ivory black to complicate the monolith of what black could be. A space to suggest that you could reach inside of it and grab the mark. The paint is materially pornographic, made of animal bone and in its own various stages of dryness and muckiness. It's the only way that I can address death in the room.

Season 1 Yeezy fashion show. The Lighting. The way it renders Black skin. The cold. Necropolitics *by Achille Mbembe. Mesmerism. Can I make you see . . . can I make you see me? Thelma's Biennial. Ebony told me she was thinking about W. E. B. Du Bois's data portraits so I go to Conceptual Fade and bring the book into the studio—she was right. Alice's* Monument Eternal. *Grossman's* Gunhead. *Benin's gates. Shirley Horn's "You're My Thrill." I imagine her singing to the most beautiful pistol. . . .*

Fig.

I've been working through my own language around the idea of a Black figure versus the idea of just the Black body. The Black academics have created a monster with this language and I hate it. I am not an Afropessimist. I don't think about Black social death because of social discomfort from being around white folks. They desire my work to make sense of their foolishness. The Black body as terminology suggests stasis and a certain kind of ability to do with it what you want. A cadaver postmortem even in life.

I'm very much alive, will fight to remain so, and there is no theory that can teach these people how not to kill me.

The Black figure allows for movement or something that evades stasis, something that evades legibility. The Black figure is something or someone that has an ability to be in a form, but also fall out of form, or return to itself and themselves differently. I am a Black figure. I am always moving even when standing still. I feel electricity coursing through my body. I am shaped by how others move around me, how a lover moves on top of me. Brad understood this, which is why I love him.

RIDE THE THIGH WITH UNSWERVING NEED FOR THE FULLNESSSSSSSS.
A figure can collapse in itself . . .

Man: Look at this fucking faggot.
Me: I'm not a man.
Man: Oh, so you a dyke.
Me: Yes, I am a Dyke.
Man: Well. . . . Fuck you then.

COLLAPSE. TAKE FORM. COLLAPSE.

Kydex is used by gun owners as the protective material for the gun itself. It's configured as the holster. Kydex and leather. I use them both to suffocate the gun, its core functional parts, and additional items that provide tension or supply. The figures present as death masks.

One leather though. Just one so that you can see what cannot be removed. Forever marked, forever stretched. The loss is permanent. This is what it feels like to be dispersed.

The Kydex has been formed with heat and pressure. I do really well with pressure. That form

removing itself and falling back into this malleable material. And you hear the sound of the vacuum press, but you don't see it. And then, I return that image or that form back into the oven so that it can degrade, degrade, degrade. Disperse. This can go on forever.

Degradation and the material trying to find its way to itself to talk to itself about itself. The figure as an invasive entity, as it evades itself or falls back into itself. Generational loss as each of us evades our selves. And there's something that can't be recovered. And in this case, there's the basicness of the elasticity that degrades itself and becomes a bit more easily formed.

Pull all the air out. Take the shape of the object. Release and there is form. Repeat. Relive. I've finally found a twin.

THE FIEFS OF RUTHFUL SPECTERS

Benin bronzes are my reference. There is the bronze itself and the wax sculpted figures and the things they carry. These Things. Talismans. I want to present the talisman of the gods of today. The street warriors and their fiefs. Nine-mm fifty-bullet magazine drums that exact an excessive violence. An extended one hundred clip of my own creation to match the myth.

Heavy but light. Anti-muses. Anti-monuments.

got a 100 shooters right outside . . . a 100 shots a 100 SHOTS . . . , cries the god.

Twenty-two-mm bullet case holders as well as 9mm bullet case holders. Palm oil. These bronzes for a Black specter's fiefdom. My anti-monuments to memorialize the woeful foot soldier and warrior.

My Orisha Ogun is present here. When you want to temper violence, when you want to suppress war, you have to feed violence to the god.

CONCEAL.
Concealment is tied to identity and how that is tied to the figuration of oneself, the intersections of identity. The self that you know yourself to be and the self that is in the streets and in different scenarios of society.

Text is where violence manifests. Whether written or spoken aloud or heard privately between others. There are people I've seen since I was a child, worn-out individuals who show up in fiction or in the streets. Toni Morrison has a character in *Sula*, Shadrack, who, suffering from postwar trauma, declares that everyone should kill themselves if they want to keep killing each other. Profane beauty when he says "Always" to Sula, without prompting. I've been around these people all my life. My own father is one, always rambling manifestos and his "word" to me as a child. I sat quietly, watching the glazing over of his eyes and the words a solid string of emotions with no punctuation. My patience was developed here now as a full adult. I listen and I make sure to make eye contact.

Man: Hey, hey, can you see me?
Me: Yes, yes. I can see you.
Man: God is coming, you know.
Me: God is already here.

I confused this man so much he walked away from me.

The kind of people on the side of the street you see, the one who is maybe the cousin, who has always lived on the street purposely because being inside is too close to capture.

One of the things that was amplified during the past two years is that many of these folks disappeared from sight. This disrupted me as I had not realized how necessary they were to me, as a grounding force or compass. The things that they would say, the utterances, the blurts, the truths that would come out of their mouths. The documents that they would produce, the material culture, the art. The text scrawled in all caps on

paper, multicolored with letters written backward like a puzzle. The man who drives a green truck that has vinyl all-caps texts of language, of "Have Gun, Will Travel." A skull sitting in the passenger seat with an American flag inside it. Those who don't necessarily engage through a vocal sharing of the language, they write it. And it still seems like a guttural yell.

This eerie moment when these folks, my grounding forces, evaporated, almost as if they were apparitions. Disappeared. People who transfigure as they do are deemed to preserve and deliver us conspiracy theories. But for a moment many of the conspiracy theories became real and I imagined them taking leave to rest and watch us from hidden places. The scrawled text and images disappeared. The loitering. The raged, drawn manifestos begging you to read and memorize. Apparitions standing on a corner no more. And that shook me to my core because even they were not a forever thing.

I wanted to make language that had that shake and unsteadiness. Eagerness and trembling. Pleading even. I saw Manthia Diawara talk about Édouard Glissant and his theory of *trembling*. Language that trembles, or what it means to tremble. If the work doesn't tremble, then it's probably not doing what it needs to do, he said. I am affirmed.

The letters on these targets shake. I wanted to render a tremble. The restraint and the delivery. Hot like lava. I am remembering the way the seers hold language in their burgundy eyes.

Summer 2021. I am watering my four o'clock flowers and the helicopters are back. I notice that my hand is shaking as I sit down the watering jug. I bring my hand close to my face to admire the tremble and look up to the sky and quietly curse the ghetto bird.

CARRY.
I am tired of this. The weight of being a threat who also must protect herself.

Horrific and yet strangely beautiful. I'm interested in showing what the results are. This is what it looks like. This is what preparation for self-defense looks like. If you want to be good at this, this is what the data is. This is what my data is, to show you all that *I'm good at this*. It's not just about a bull's-eye; I'm giving you information about my emotional state and my composure. This emotional state varies depending on the image that I'm facing. My aim is better because I practice without the bullet, I practice without this inherent puncture, which allows me to see myself first.

I have learned how to read a new language, to show precision and aim in a very different way, so that when I get to the range and there is the puncture, I am aware of what is at stake. It's a terrifying position, but it's also a space of preparedness that I am invested in.

I utilize four different guns in this project. An AR15, a 9mm Smith & Wesson, a 9mm Glock 48, and a 22mm Walther. Each has its own signature and difficulty based on the weight, the way it draws and handles, the way that it works with my body. And there is a certain kind of knowledge that I have developed and produced, and it's inherently mine.

Training to failure is overloading your weights over a significant period of time to create a forced neurological break from the physical body during your reps. This can generate two outcomes: a surprising display of strength, what they call a "good push," or a complete and utter breakdown in which you simply cannot bypass the neurological break. What happens after is a period of recovery, overnight and across a couple of days, that allows the muscles breaking down to rebuild, creating what we know as muscle gain—extreme extrusions of internal scars.

Alongside this work, I have been *training to failure* through a weight-lifting practice. I have been measuring my own gains in the physicality of holding each gun and measuring the advancements of my shots over time.

Training to failure can also be understood in relationship to this process of unmasking that I am undergoing as an autistic person. To *mask* as an autistic person is a form of psychological *training to failure*. I can push myself to forgo physical and psychological pain and discomfort and am constantly trying to force a break between the mind and the body, so that I can appear neurotypical or what is read as normal behaving. The gains are always false and temporary.

When you train to shoot, you are looking for gains in precision that if too extreme touch up against a sociopathic engagement with the device. The less you acknowledge your physical pain, which can occur if you shoot too much, is similar. The desire for the push comes forward. Sweat is present; physical ache is present because of the kickback, depending on the pistol.

You're my thrilllllll.... DRILLLLLL.

Walking. Suffocating. Precision.

The form removes itself and falls back into this malleable material. This is degradation. The figure as an invasive entity evades itself or collapses back into itself. In a sense, there is loss. There's generational loss as each thing evades itself. And there's something that can't be recovered. And in this case, there's the basicness of the elasticity that annihilates itself to allow itself to be formed again, and again.

I track my walking in my studio. It's the safest place for this. The data reads as an elegant trace, this archival trace, that is in real time and shows what I carry with my gait. Depending on the gun, the pressure against my hip, against my crotch,

is comforting. Is this what having a hard dick feels like? If so, it's uncompromising. I develop a sense of loss without it when I travel beyond state lines. To think about what is needed to execute a good shot is about a lack of fear, a lack of affect, and a precise sharpness that borders into a sociopathic-type mind state.

What Black data has meant to this country has been something very specific that has a lot to do with dire needs. The data that I'm rendering is of an individual. This is just me. And it's also excellence. It's not something that is of a particular void. I'm actually exploiting the data of what it means to be a good shooter or what it means to be good at this particular thing that is causing me trouble. It's a hard thing.

There is statistic and data training and trying to get a certain kind of marksmanship, but then there's the reality of awareness of life that's in front of you.

In fifteen seconds, I can identify the device that makes the gun work and remove it, leaving it without function. I practice this in ten-minute intervals per gun.

At the end of the day this is what I do. I learn how to do things in order to take them apart.

MASK / CONCEAL / CARRY

BLACK INSANITY ON THE LEDGE OF A
 DEATH STAR
I DONT PLAY ABOUT ME
INNER CRITIC
SIDE BY SIDE YA
SPINNING FOR GHOST
THIS IS A DRILL
BIG STEPPER
NEVER AGAIN
WALK YOU DOWN
DEATH SLUR
DRAW HOLD LAND HAND OFF TRIGGER
SIGNATURE OF THE CALIBER
YOUR SPIRIT WILL KILL YOU TRYING
 TO LIVE SO YOU MIGHT AS WELL
 COOPERATE
ANXIETY OF ANNIHILATION
MY TRACE MY RUIN
NOCTURNAL BODY
BLACK RAGE
NO RECONCILIATION
BLOW ITSELF UP
THE FIEFS OF RUTHFUL SPECTERS
THE END OF THE WORLD HAS ALREADY
 OCCURRED
A RELATION WITHOUT DESIRE
TODAY VICTIM TOMORROW
 EXECUTIONER
THE DESIRE FOR AN ENEMY
EXISTENTIAL ENEMIES
PROTECTIVE FIGURES
DONT GIVE ME FLOWERS
USE YOUR RANK WISELY
IT ALL FALLS APART
HIGH DREAM
TRAINING TO FAILURE
WE NEED OUR PROJECTIONS
FEED OFF OF ME
YOU TALK A GOOD GAME BUT WE KNOW
AT GREAT COST
SURVIVORS GUILT
PAIN DEAFEN
HOW TO HOLD EVERYTHING AT ONCE
YOUR CONSTRUCTS ARE SUFFOCATING
 ME

IN OUR WOUNDS WE ARE NOT
 TRUSTWORTHY
VICTIM OF THEIR PROJECTIONS
WHO IS THEY
GODS WITH GUNS
LETS JUST END IT ALL NOW
WILL TO KILL WILL TO CARE
POSTFACT WORLD
SELF GAZING
THE CONTENT IS IN THE FORM
NOCTURNAL GRACE
SEVERE ELEGANCE
ABJECT FAILURE
COMFORT TROPES
SILHOUETTES & THINGS
EXHAUSTIVE DESPAIR
SLANTS LIKE A RAZOR
PITY DARKENS
DARK FISSURES
CUTS A DARK FIGURE
THE SHAME OF STASIS
ONE SHOT TWO SHOT THREE SHOT ME
CUTS A THREATENING FIGURE
I AM TREMBLING CANT YOU SEE
YOURE MY THRILL
STUDY OR ELIMINATE
IF THIS IS THE LOVE THE GODS SENT
 WHAT ELSE COULD I DO
WE ARE COLLAPSING
WHO IM FINNA TEACH WITH THEORY
 HOW NOT TO KILL ME?!

PLATES

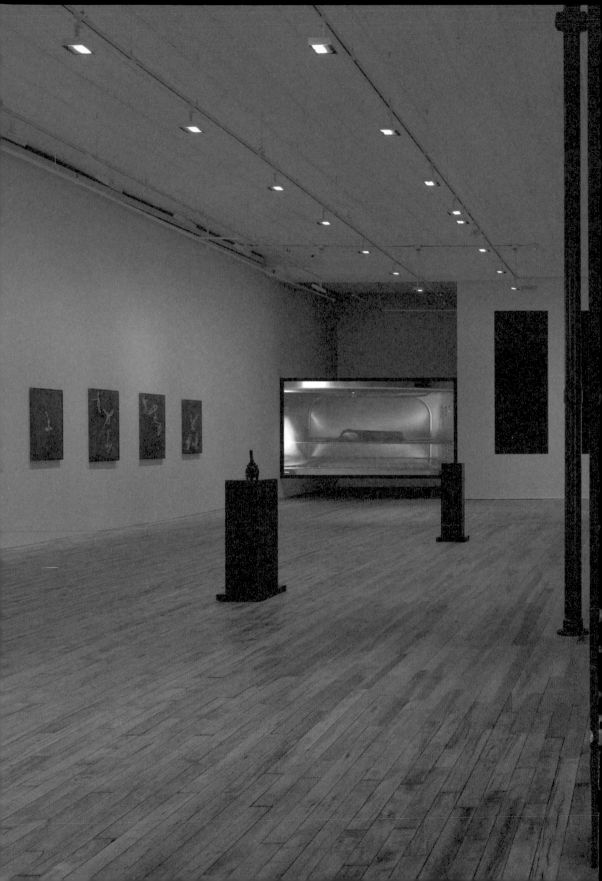

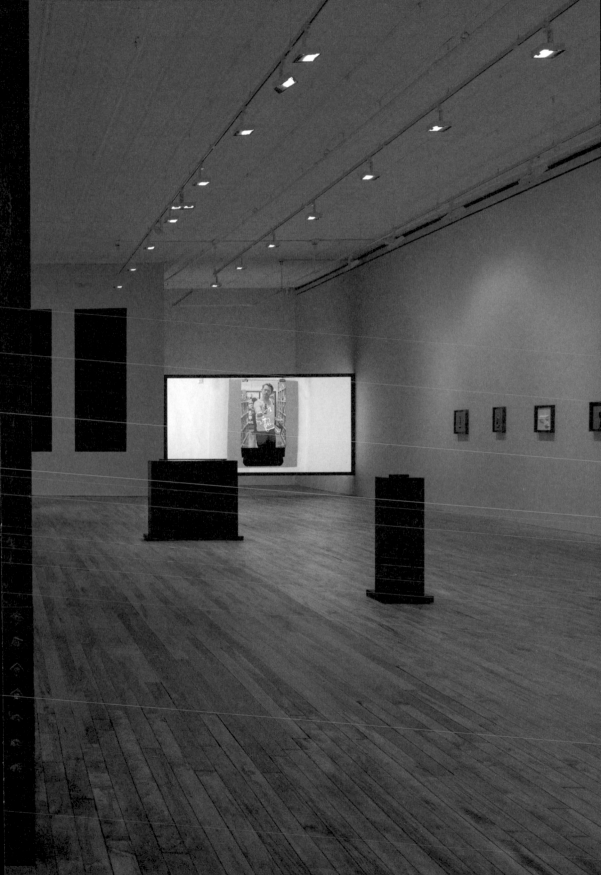

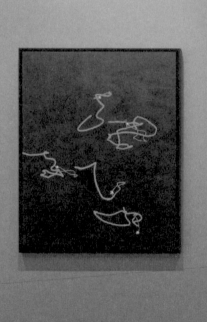
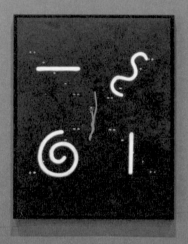

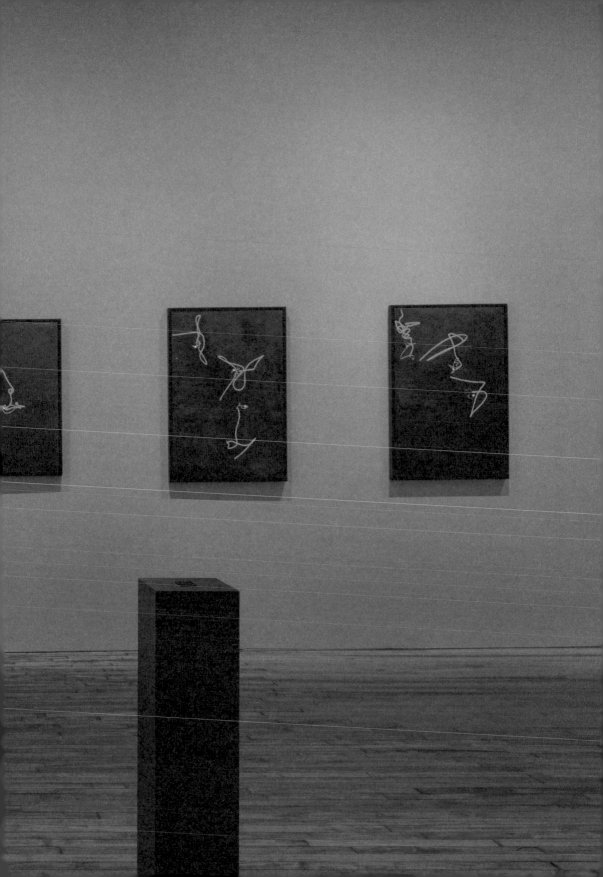

A Study in Qualification 79.6 22mm / 87.0 22mm / 86.3 22mm, 2022
Acrylic and oil on canvas in artist's frame
39 ½ × 26 ⅝ × 1¾ inches | 100.3 × 67.6 × 4.5 cm

46

A Study in Qualification 89.9 AR15 / 97.6 AR15 / 98.1
AR15 / 95.9 22mm / 92.9 AR, 2022
Acrylic and oil on canvas in artist's frame
46 ½ × 36 ¾ × 1 ¾ inches | 118.1 × 93.3 × 4.5 cm

A Study in Qualification DSM5 – 97.6 22mm, 2022
Acrylic on canvas in artist's frame
46 ½ × 36 ¾ × 1 ¼ inches | 118.1 × 93.3 × 4.5 cm

A Study in Qualification 82.6 22mm, 2022
Acrylic on canvas in artist's frame
35 ⅝ × 23 ⅝ × 1 ¾ inches | 90.5 × 60 × 4.5 cm

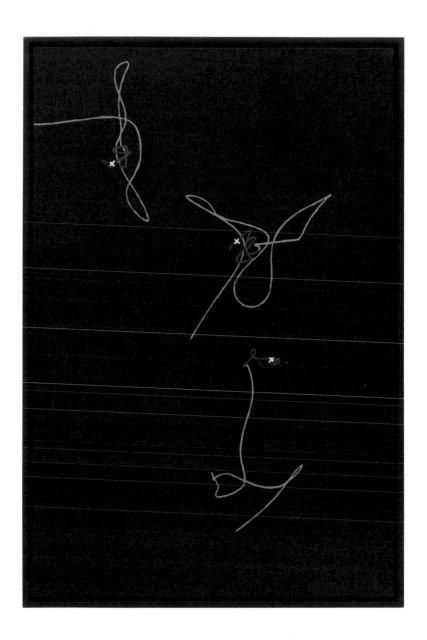

A Study in Qualification 93.8 Smith + Wesson 9mm /
91.2 Smith + Wesson 9mm / 90.2 Smith + Wesson 9mm, 2022
Acrylic and oil on canvas in artist's frame
39 ½ × 26 ½ × 1 ¼ inches | 100.3 × 67.3 × 4.5 cm

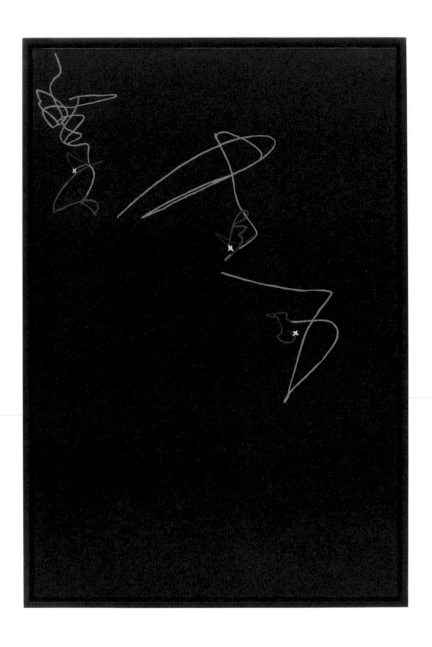

A Study in Qualification 91.8 22mm / 94.5 Glock 48 /
92.7 Smith + Wesson 9mm, 2022
Acrylic on canvas in artist's frame
39 ½ × 26 ½ × 1 ¾ inches | 100.3 × 67.3 × 4.5 cm

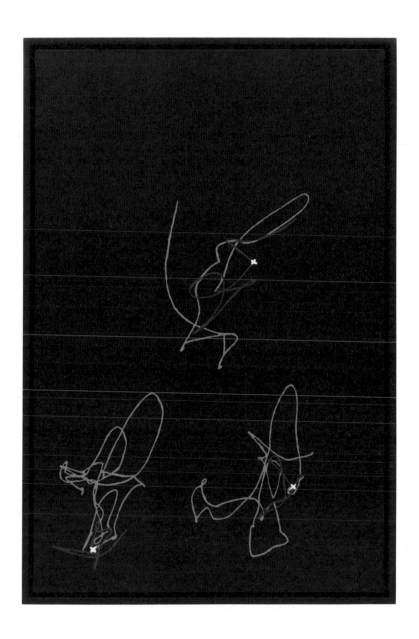

A Study in Qualification 95.6 Glock 48 9mm / 97.3
Glock 48 / 98.2 Glock 48, 2022
Acrylic and oil on canvas in artist's frame
35 ⅝ × 23 ⅝ × 1 ¾ inches | 90.5 × 60 × 4.5 cm

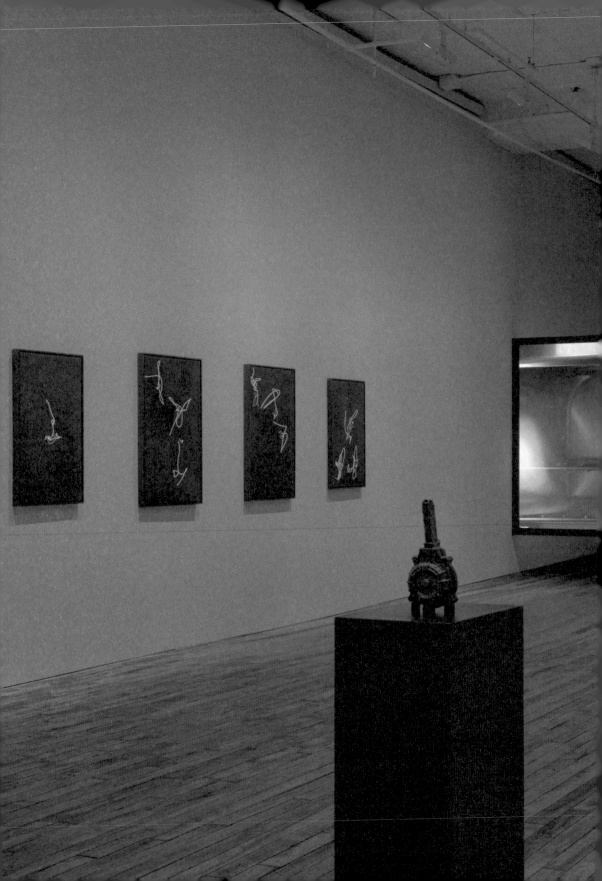

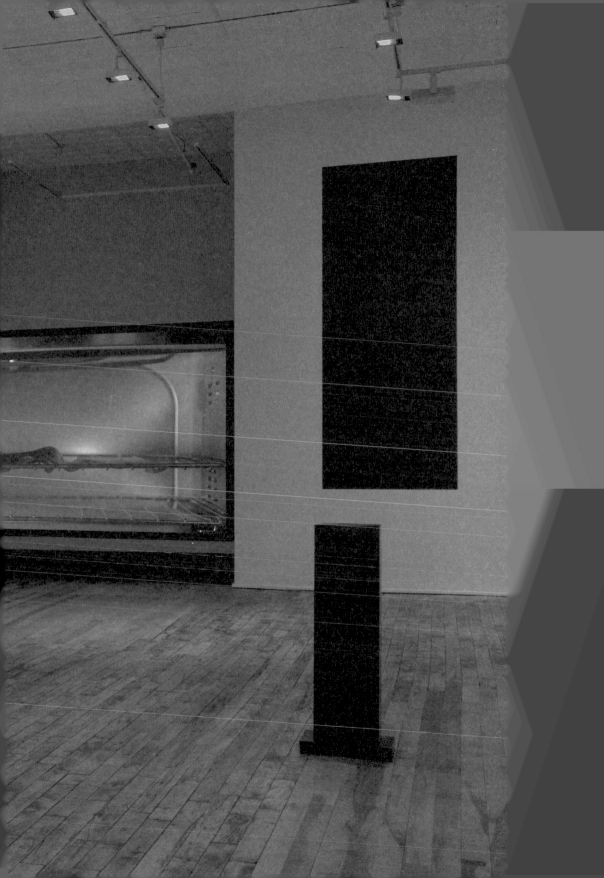

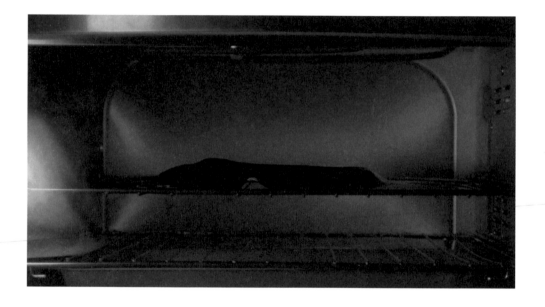

Cuts a dark figure…, 2022
Single-channel video, color, 9:30 min., sound
Overall dimensions variable

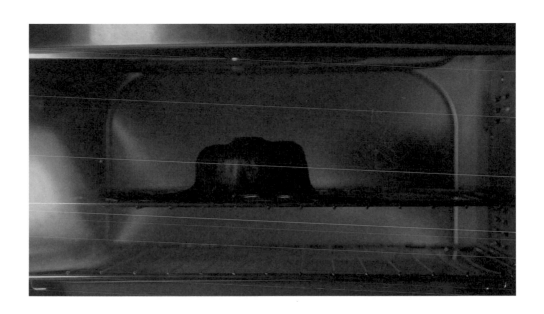

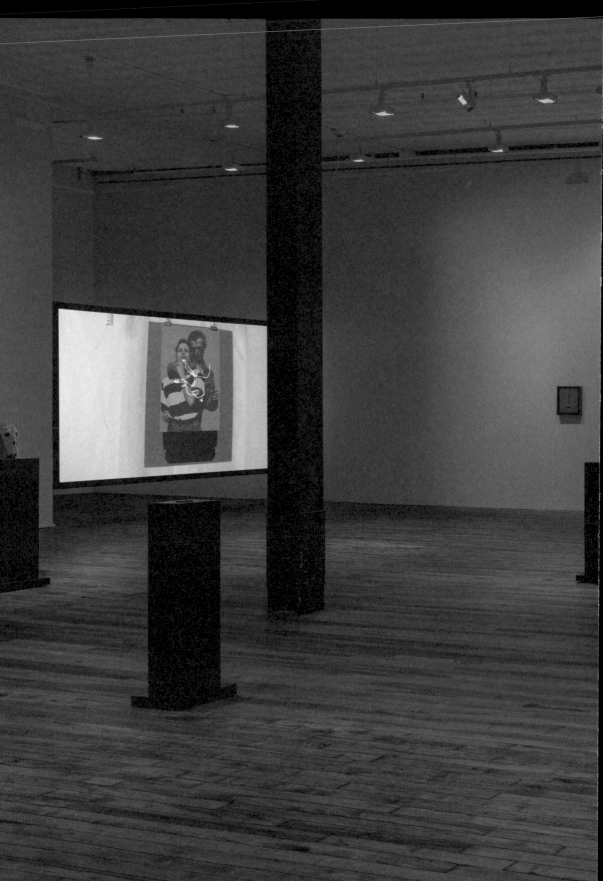

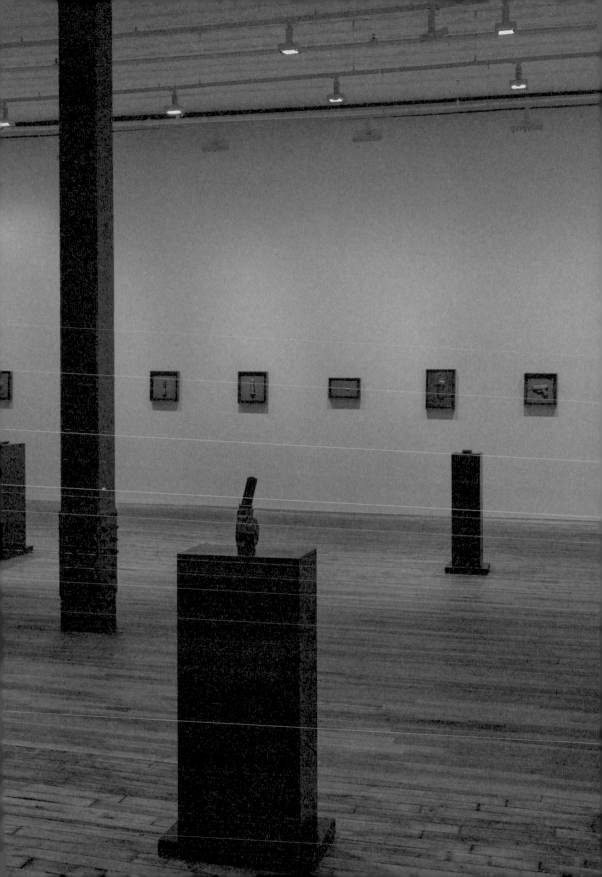

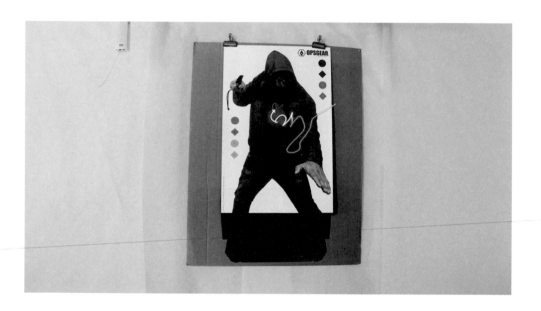

Precision, in spite of a threatening figure, 2022
Single-channel video, color, 9:30 min., sound
Overall dimensions variable

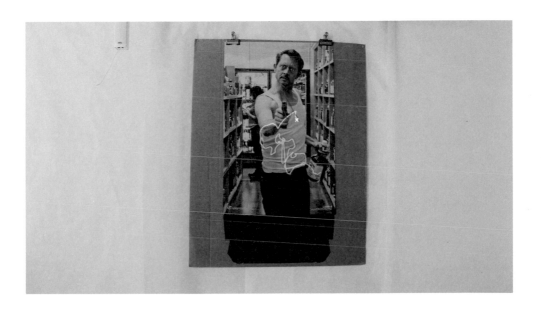

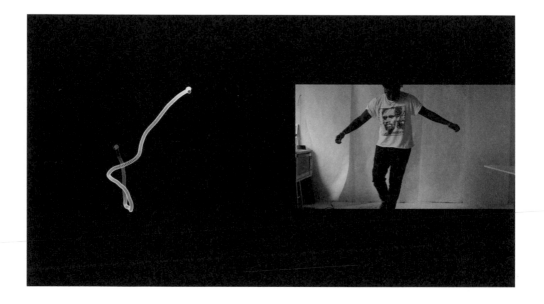

To wend one's way…, 2022
Two-channel video, color, 2:45 min.
Overall dimensions variable

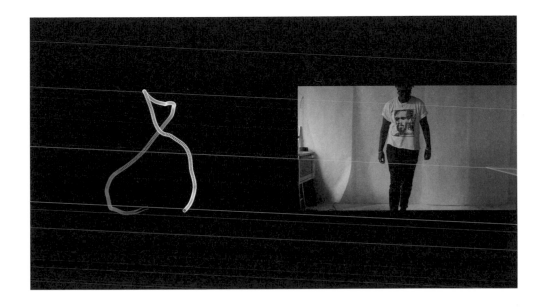

THE FIEFS OF RUTHFUL SPECTERS – DRUMMER
Oh how we will die for you, a thousand deaths, drums
for the god till our hands bleed, endlessly, 2022
Bronze with black patina and palm oil
9 ½ × 4 ¼ × 2 ½ inches | 24.1 × 10.8 × 6.3 cm

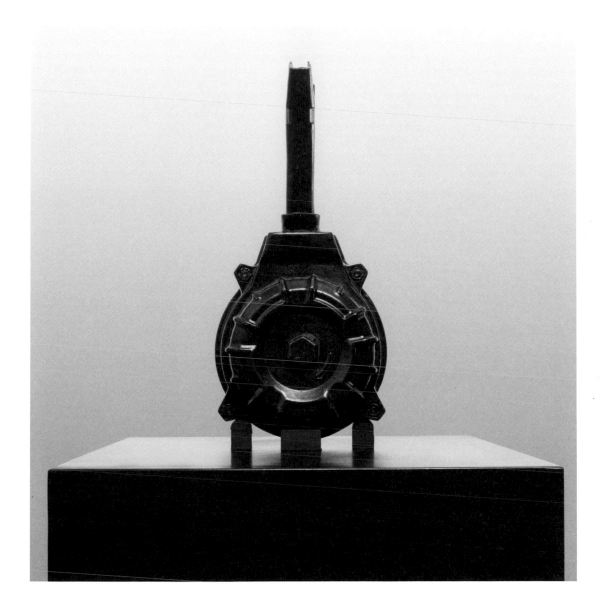

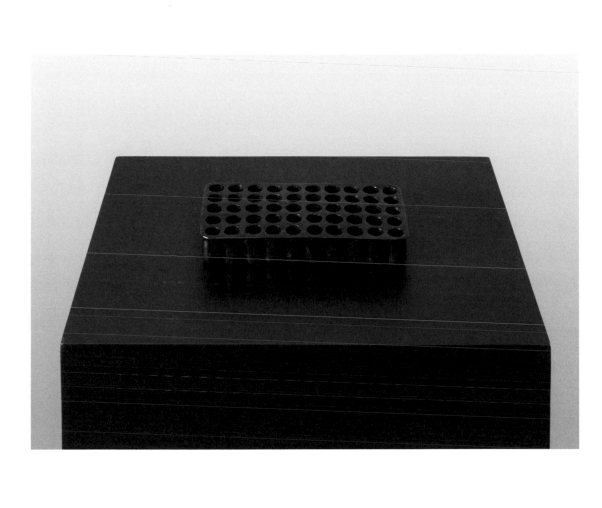

THE FIEFS OF RUTHFUL SPECTERS –
The Caliber of Specters II, 2022
Bronze with black patina and palm oil
⅛ × 2 ⅞ × 1 ½ inches | 0.3 × 7.3 × 3.8 cm

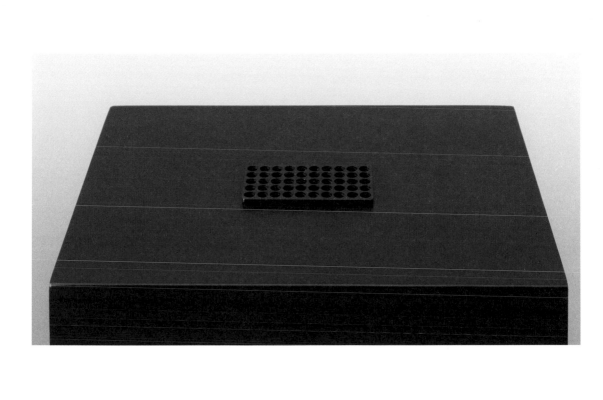

THE FIEFS OF RUTHFUL SPECTERS – THE SWORDSMAN
Not many shall reach the gaze of the light at the end of this, 2022
Bronze with black patina and palm oil
1⅛ × 32⅞ × 1⅝ inches | 2.9 × 83.5 × 4.1 cm

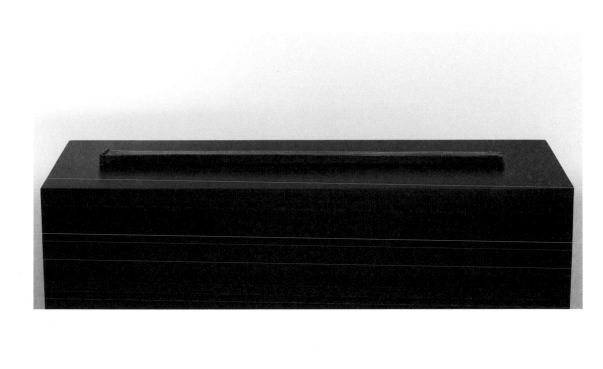

If you had ever thought that you saw me let me assure you that you have not seen
me as I know my self because I have not found you worthy of this image, 2022
10k gold, 925 silver, German silver, stainless steel, 24k gold thread, and sweat
11 × 8 × 10 inches | 27.9 × 20.3 × 25.4 cm

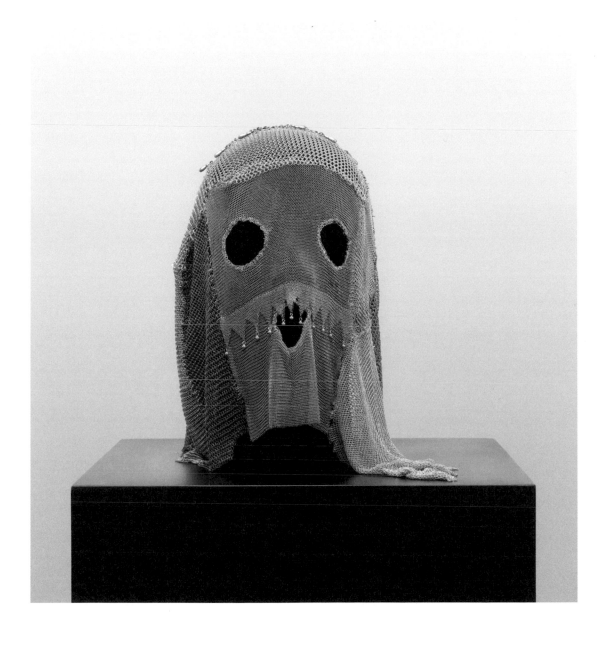

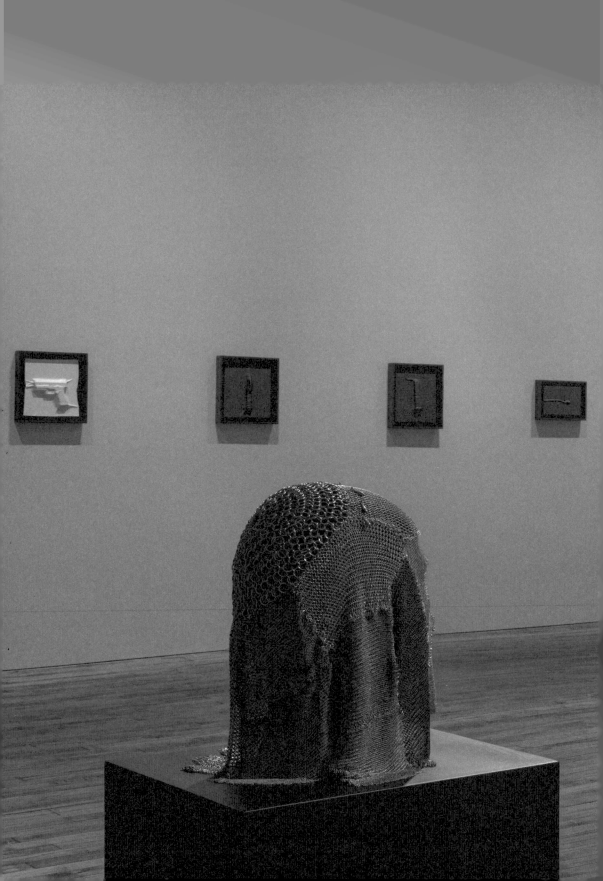

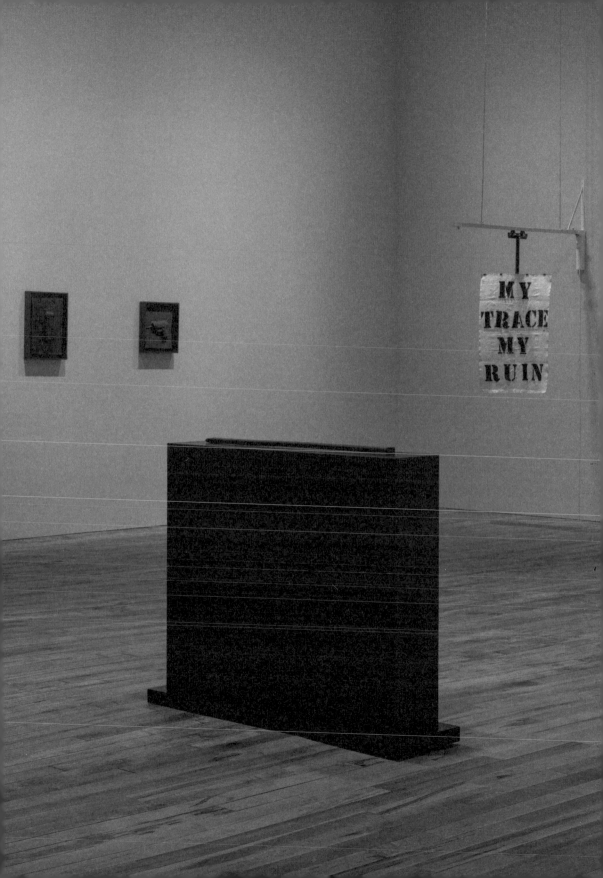

Fig. VII. AR15 Tactical Charging Handle, 2022
Kydex in artist's frame
15 ½ × 13 ½ × 2 ¼ inches | 39.4 × 34.3 × 5.7 cm

Fig. I. AR15 Bolt Carrier Group, 2022
Kydex in artist's frame
15 × 14 ½ × 2 ¼ inches | 38.1 × 36.8 × 5.7 cm

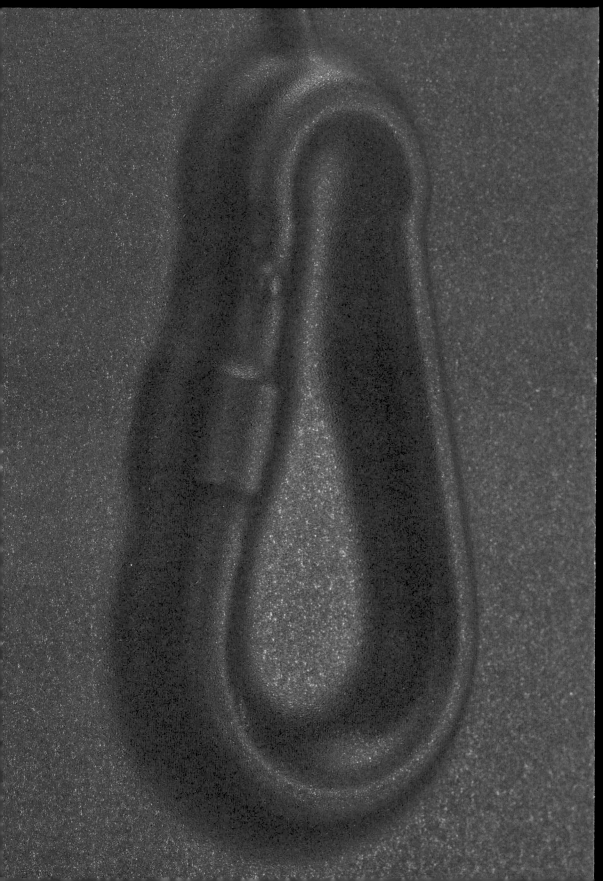

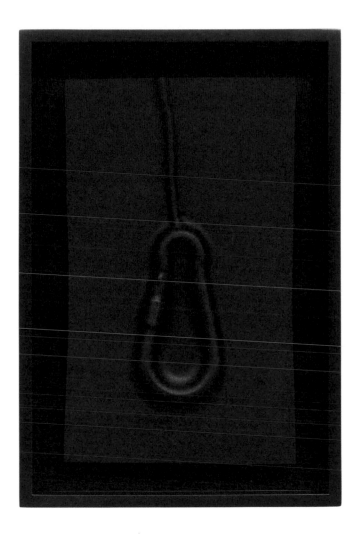

Fig. IX. Carabiner, 2022
Kydex in artist's frame
15 ⅛ × 10 ¼ × 2 ¼ inches | 38.4 × 26 × 5.7 cm

Fig. II. G48, 2022
Kydex in artist's frame
14 ¾ × 14 ¾ × 2 ¼ inches | 37.5 × 37.5 × 5.7 cm

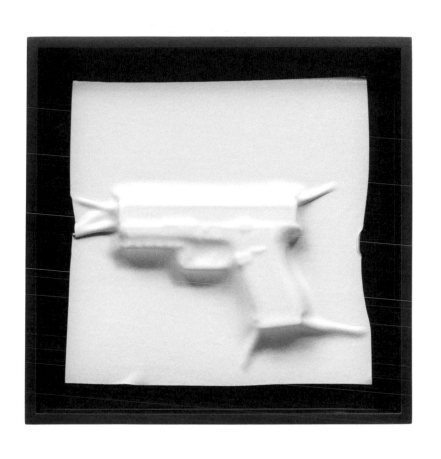

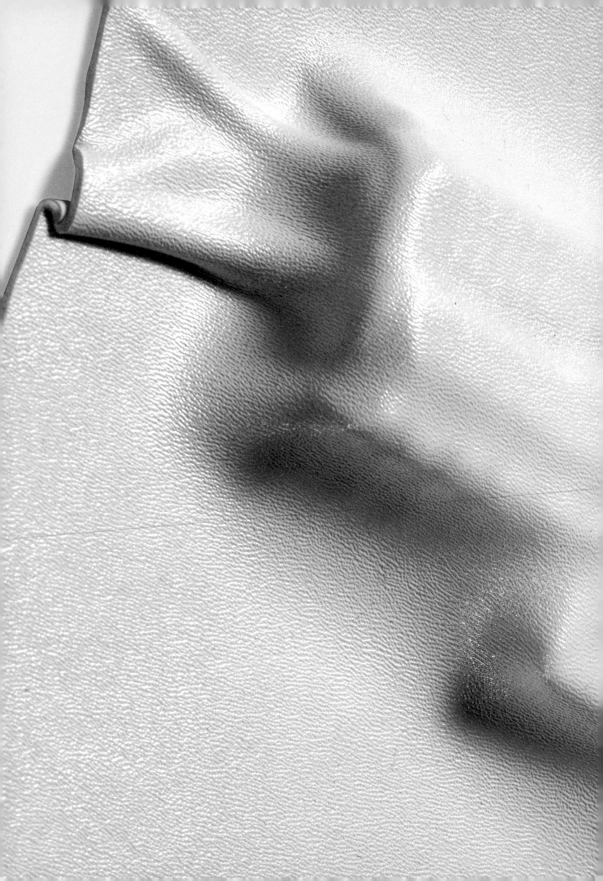

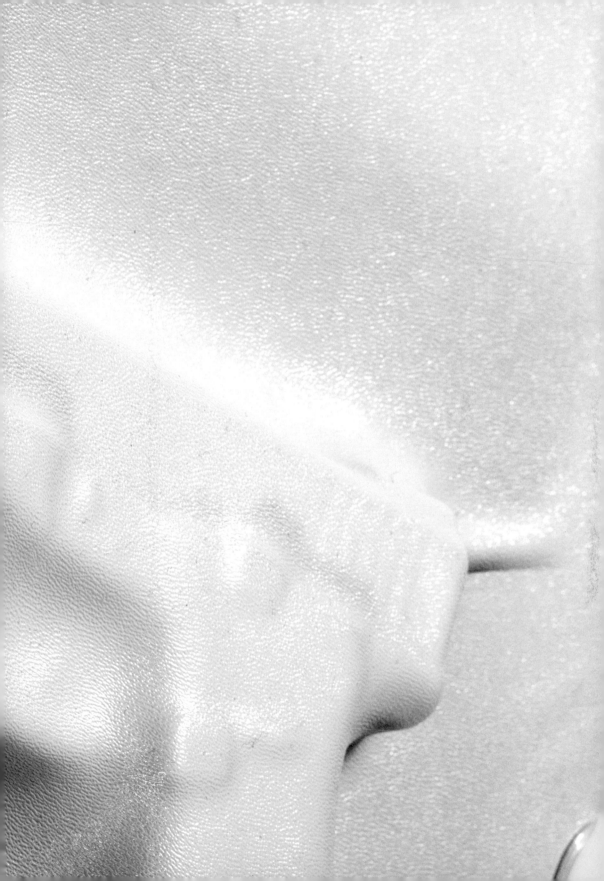

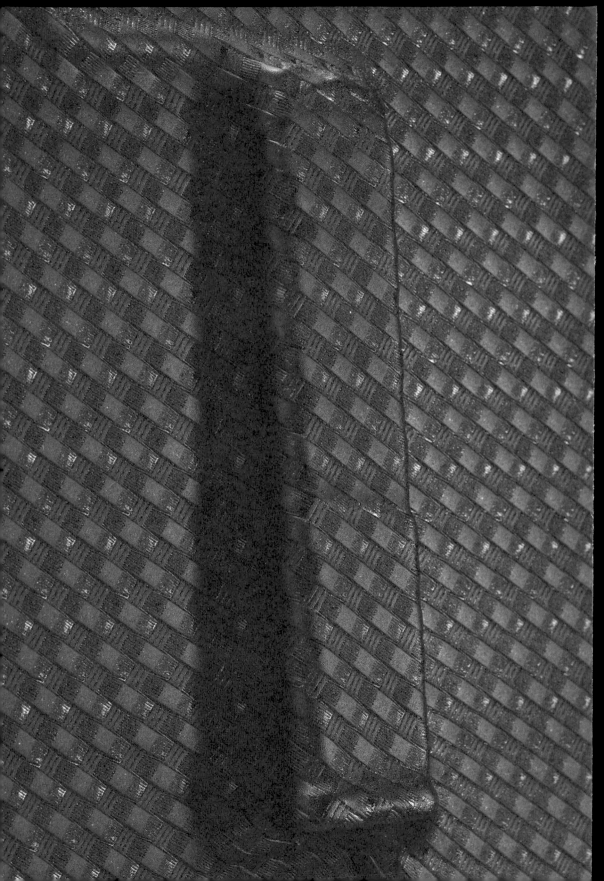

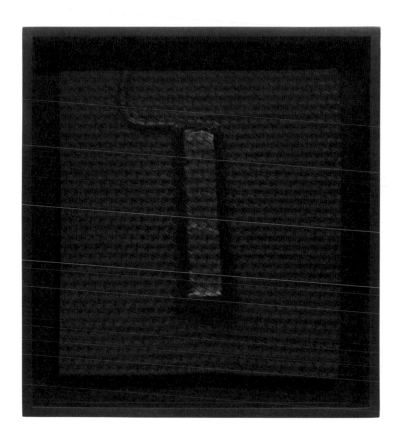

Fig. IV. 9mm Extended Clip, 2022
Kydex in artist's frame
15 ¾ × 14 ⅜ × 2 ¼ inches | 40 × 36.5 × 5.7 cm

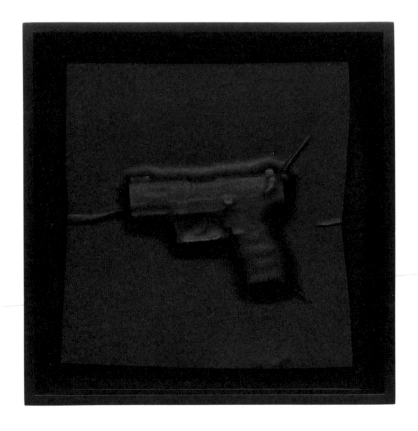

Fig. VIII. W 22mm, 2022
Kydex in artist's frame
14 ¾ × 14 ¼ × 2 ¼ inches | 37.5 × 36.2 × 5.7 cm

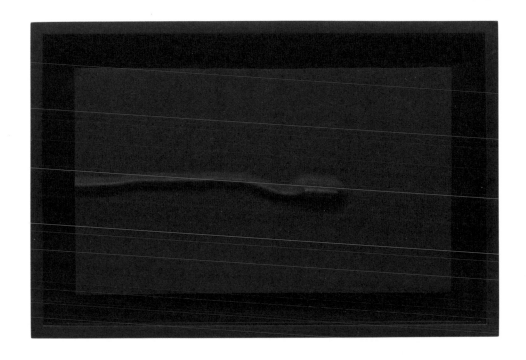

Fig. VI. 9mm Bullet, 2022
Kydex in artist's frame
10 ¼ × 15 ⅛ × 2 ¼ inches | 26 × 38.4 × 5.7 cm

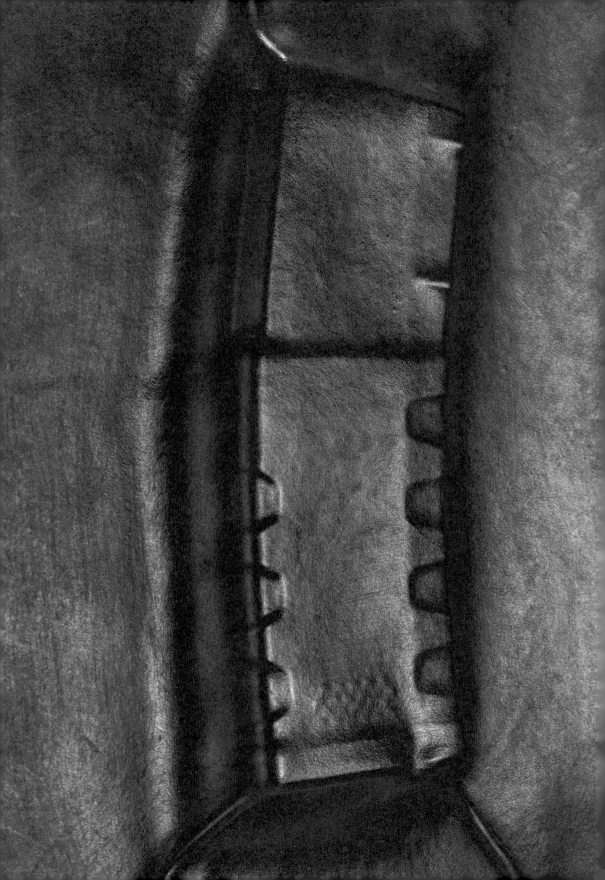

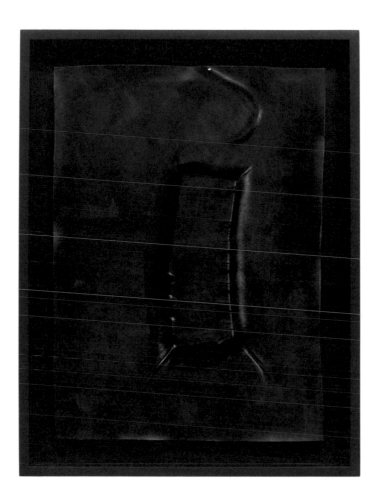

Fig. V. AR15 Magazine Leather, 2022
Leather with black dye, Saphir shoe polish, and spit in artist's frame
18 ½ × 14 ¼ × 2 ¼ inches | 47 × 36.2 × 5.7 cm

MASK CONCEAL CARRY, 2022
Vintage ivory black pigment, acrylic, pumice, and dirt on canvas
46⅛ × 26 inches | 117.2 × 66 cm

MASK

CONCEAL

CARRY

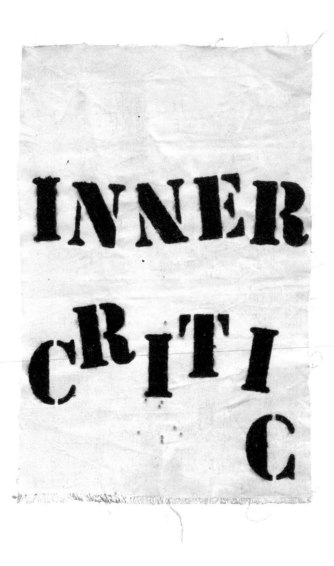

INNER CRITIC, 2022
Vintage ivory black pigment, acrylic, pumice, and dirt on canvas
35 × 22 ⅛ inches | 88.9 × 56.2 cm

MY TRACE MY RUIN, 2022
Vintage ivory black pigment, acrylic, pumice, and dirt on canvas
35 × 22 ½ inches | 88.9 × 57.1 cm

THE DESIRE FOR AN ENEMY, 2022
Vintage ivory black pigment, acrylic, pumice, and dirt on canvas
48 × 38 inches | 121.9 × 96.5 cm

BLOW ITSELF UP, 2022
Vintage ivory black pigment, acrylic, pumice, and dirt on canvas
34 × 21 ½ inches | 86.4 × 54.6 cm

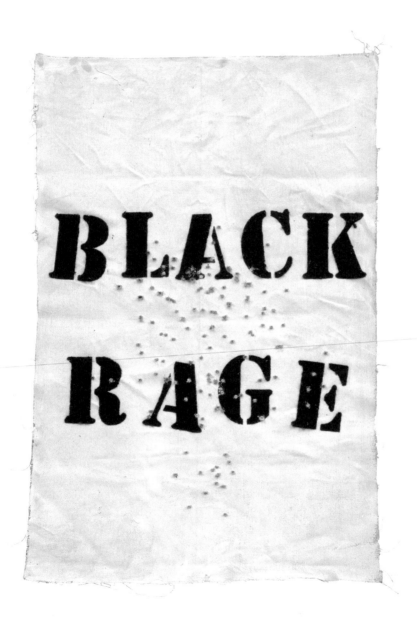

BLACK RAGE, 2022
Vintage ivory black pigment, acrylic, pumice, and dirt on canvas
38 ⅛ × 24 ½ inches | 96.8 × 62.2 cm

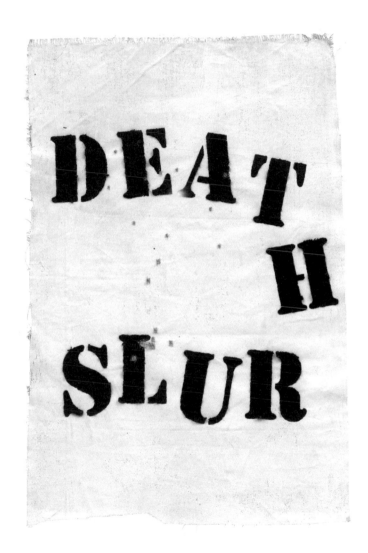

DEATH SLUR, 2022
Vintage ivory black pigment, acrylic, pumice, and dirt on canvas
34 ¾ × 22 ⅛ inches | 88.3 × 56.2 cm

NO WHITE FLAGS, 2022
Vintage ivory black pigment, acrylic, pumice, and dirt on canvas
34 × 22 ⅛ inches | 86.4 × 56.2 cm

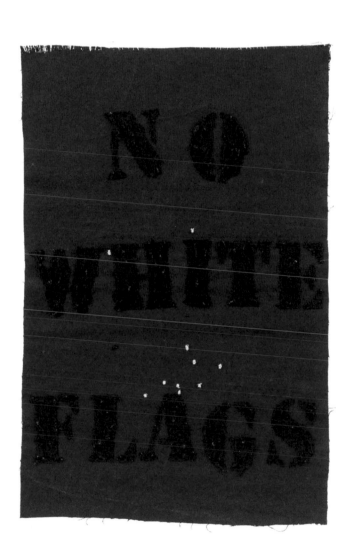

MY SHADOW SELF, 2022
Vintage ivory black pigment, acrylic, pumice, and dirt on canvas
45 ½ × 25 ¼ inches | 115.6 × 64.1 cm

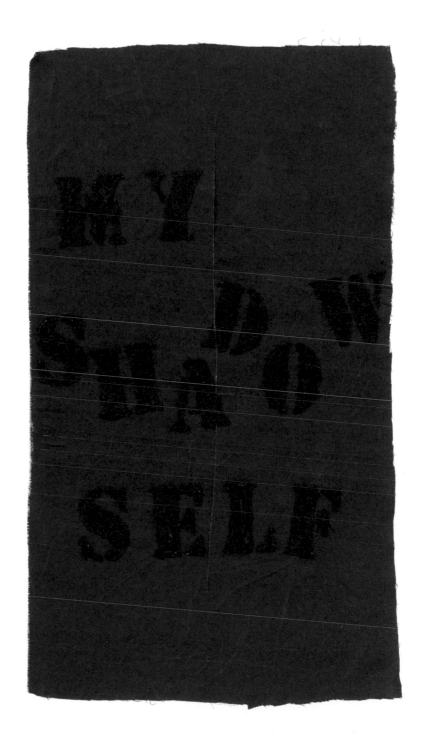

I Don't Believe in Trigger Warnings Anymore, 2022
Acrylic sheet and card stock
6 × 6 ½ inches | 15.2 × 16.5 cm

Tiona Nekkia McClodden
Blytheville, AR (AFB)
b. 1981

I Don't Believe in Trigger Warnings Anymore, 2022

The trigger warning has become a fetish based on the desire to disturb and be disturbed simultaneously. The desire for the feeling of this effect has become a kink for some. I'd rather make a statement and stand behind that position, no matter the difficulty. This is with the knowledge that the concept of harm is subjective and the fact that I will now have to expose my relationship to the material instead of passing it on mindlessly as if a baton while hiding behind an assumed collective response.

What hurts you does not inherently hurt others and vice versa. When one has already seen the content that they are now trying to hide all while sharing it at the same time, what kind of sense does this make?

So perhaps instead, ask yourself, why am I sharing this material or content online or in space in the first place? If you cannot answer this question honestly or speak from your position about the content, then refrain from sharing anything at all and move on like the rest.

Please do not assume that you are protecting or warning anyone by simply posting "TW". I find *that* offensive.

Courtesy of the artist.

David Zwirner and Ebony L. Haynes wish to thank Tiona Nekkia McClodden, without whom this exhibition and publication would not have been possible. Thanks are due to Simone White for her illuminating conversation with the artist and to Rhea Dillon.

For their work on the exhibition, we are grateful to Rebecca Ashby-Colón, Claire Ball, Susan Cernek, Allison Chipak, Cristina Covucci, Karryl Eugene, Clara Gordon, Jordan Kelly, Coco Kim, Vida Lercari, Thomas Ling, Julia Lukacher, Alyssa Mattocks, Kerry McFate, Sean Morgan, Clive Murphy, Julian Phillips, Kyle Rafferty, Robert Richburg, Gabriela Scopazzi, Janna Singer-Baefsky, Virginia Stroh, and Nora Woodin.

Thank you to Andrea Hyde for the catalogue series design and, for their work on this volume, to Sergio Brunelli, Luke Chase, Anna Drozda, Fabio Ferrandini, Zeno Ferrandini, Doro Globus, Elizabeth Gordon, Jessica Palinski Hoos, Amy Hordes, Daniela Ioan, Mari Perina, Molly Stein, Jules Thomson, Joey Young, and Lucas Zwirner.

The artist would like to thank her Baba Johnny, Rhea Dillon, Simone White, Danielle Deadwyler, James Maurelle and Ladi'Sasha Jones, and Courtney Willis Blair.

Collections

p. 46: Collection of Rashid Johnson and Sheree Hovsepian
p. 47: Collection of Dr. Paul Marks and family, Toronto
pp. 48, 87: Collection of Brian McCarthy and Daniel Sager
p. 71: Rennie Collection, Vancouver
p. 77: Collection of Noel E. D. Kirnon
p. 79: Private collection
p. 83: Family Servais Collection, Brussels
p. 84: Collection of Debbie and Glenn August
p. 85: Collection of Marc Selwyn, Los Angeles
pp. 92, 103: Collection of Stephanie and Michael Ferdman

Photography

pp. 9, 19, 20, 21, 40–41, 42–43, 52–53, 56–57, 63, 65, 67, 69, 71, 72–73, 76, 80–81, 82, 86, 107: Kerry McFate
pp. 10, 89, 90–91, 92, 93, 95, 97, 98–99, 100, 101: Maris Hutchinson
pp. 12–13, 14–15, 16–17, 18, 22: Tiona Nekkia McClodden
pp. 45, 46, 47, 48, 49, 50, 51, 74, 75, 77, 79, 83, 84, 85, 87, 103, 105: Stephen Arnold

The *Clarion* series is an essential component of 52 Walker programming. An edition accompanies every exhibition, highlighting and expanding on the show's conceptual theses through newly commissioned texts, interviews, archival materials, and artistic interventions. The series is named in honor of the renowned author Octavia E. Butler, who was first published in the 1971 Clarion Science Fiction and Fantasy Writers' Workshop anthology.

Other Titles in the *Clarion* Series
I. Kandis Williams: A Line
II. Nikita Gale: END OF SUBJECT
III. Nora Turato: govern me harder

Forthcoming Titles
V. Tau Lewis: Vox Populi, Vox Dei
VI. Gordon Matta-Clark and Pope.L: Impossible Failures

Published by 52 Walker and
David Zwirner Books
on the occasion of

Tiona Nekkia McClodden:
MASK / CONCEAL / CARRY
52 Walker, New York
July 13–October 8, 2022

52 Walker
52 Walker Street
New York, New York 10013
+1 212 727 1961
52walker.com

David Zwirner Books
520 West 20th Street, 2nd Floor
New York, New York 10011
+1 212 727 2070
davidzwirnerbooks.com

Editor: Ebony L. Haynes
Project Editor: Elizabeth Gordon
Editorial Coordinator: Jessica Palinski Hoos
Proofreader: Anna Drozda

Design: Andrea Hyde
Photography coordination: Rebecca Ashby-Colón,
　Virginia Stroh
Production Manager: Luke Chase
Color separations: VeronaLibri, Verona
Printing: VeronaLibri, Verona

Typefaces: DTL Fleischmann, Genath
Paper: Magno Natural, 140 gsm

ISBN 978-1-64423-108-1

Library of Congress Control Number: 2023938513

Printed in Italy

Notes

Notes